PAINTING
WILDLIFE
TEXTURES
Step by Step

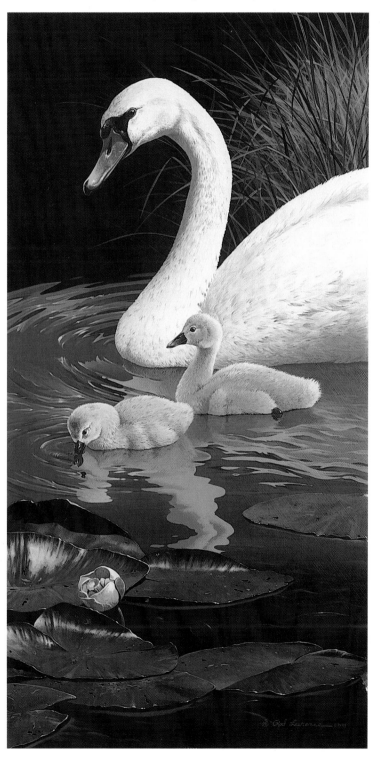

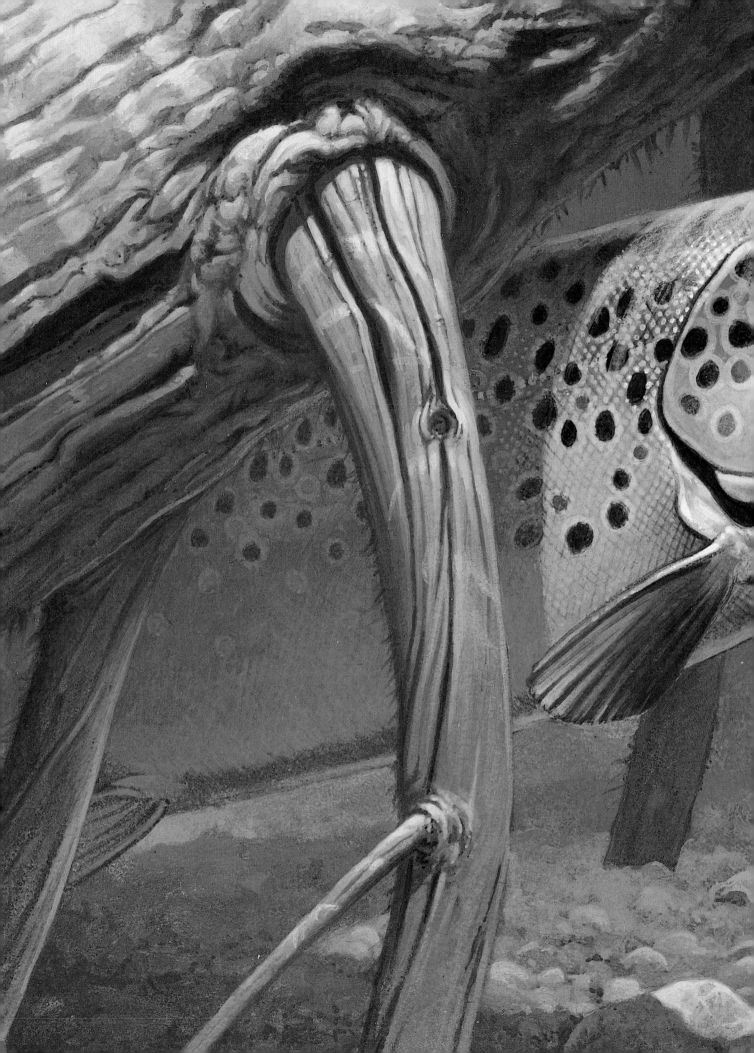

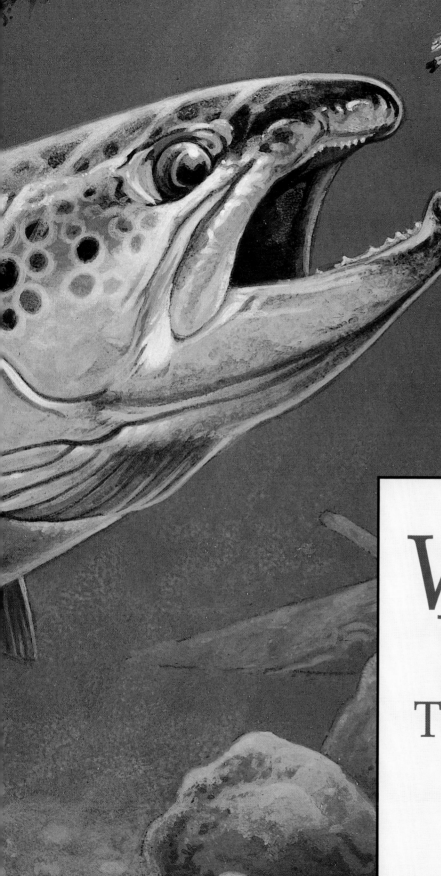

PAINTING
WILD
LIFE
TEXTURES
Step by Step

ROD LAWRENCE

NORTH LIGHT BOOKS
CINCINNATI, OHIO

ABOUT THE AUTHOR

Rod Lawrence graduated magna cum laude with a fine arts degree from the University of Michigan in 1973. Since then he has been working full-time as a professional artist. Some of his credits include being

named the Michigan Ducks Unlimited Artist of the Year in 1979 and MUCC's Michigan Wildlife Artist of the Year in 1981. Lawrence also had the winning designs for the 1983 and 1990 Michigan Duck Stamps, as well as the 1981, 1987 and 1992 Michigan Trout Stamps. His unprecedented double win for both the 1995 Michigan Duck Stamp and the 1995 Michigan Trout Stamp make him the only artist to have won seven Michigan stamp design contests.

Lawrence has exhibited in numerous group and one-man shows, including the prestigious Leigh Yawkey Woodson Art Museum's "Birds in Art" and "Wildlife: The Artist's View" shows. From these shows, his work has been

chosen several times for their national tour. His art has also appeared as covers and illustrations, and been featured in many outdoor magazines. Several sets of limited edition collector plates feature his work. He is also an active instructor for wildlife art workshops.

A log cabin in the hardwoods of northern Michigan, overlooking the north branch of the Manistee River, is home for Lawrence and his family. The symbol preceding his signature in each of his paintings illustrates the importance of his family in his work. The oddly shaped "S" is for his wife, Susan (an accomplished basket maker and instructor), and the "M" and "B" represent their sons, Matthew and Brett.

Painting Wildlife Textures Step by Step. Copyright © 1997 by Rod Lawrence. Printed and bound in Singapore. All rights reserved. No part of this book may be reproduced in any form or by any electronic or mechanical means including information storage and retrieval systems without permission in writing from the publisher, except by a reviewer, who may quote brief passages in a review. Published by North Light Books, an imprint of F&W Publications, Inc., 1507 Dana Avenue, Cincinnati, Ohio 45207. (800) 289-0963. First paperback edition 2001.

Other fine North Light Books are available from your local bookstore, art supply store or direct from the publisher.

05 04 03 02 01 5 4 3 2 1

Library of Congress has catalogued hard cover edition as follows:

Lawrence, Rod
 Painting Wildlife Textures Step by Step / Rod Lawrence.
 p. cm.
 Includes index.
 ISBN 0-89134-669-4 (hard cover)
 1. Wildlife art. 2. Painting—Technique. I. Title.
 ISBN 1-58180-177-7 (pbk: alk. paper)

ND1380.S46 1996
751.4—dc20

Edited by Rachel Rubin Wolf
Designed by Sandy Conopeotis Kent

METRIC CONVERSION CHART

TO CONVERT	TO	MULTIPLY BY
Inches	Centimeters	2.54
Centimeters	Inches	0.4
Feet	Centimeters	30.5
Centimeters	Feet	0.03
Yards	Meters	0.9
Meters	Yards	1.1
Sq. Inches	Sq. Centimeters	6.45
Sq. Centimeters	Sq. Inches	0.16
Sq. Feet	Sq. Meters	0.09
Sq. Meters	Sq. Feet	10.8
Sq. Yards	Sq. Meters	0.8
Sq. Meters	Sq. Yards	1.2
Pounds	Kilograms	0.45
Kilograms	Pounds	2.2
Ounces	Grams	28.4
Grams	Ounces	0.04

DEDICATED TO MY FATHER, PHILIP,
THE ARTIST THAT STARTED IT ALL,
AND MY MOTHER BARBARA;
TO MY TWO SISTERS, CATHY AND DEBRA,
WHO SHARE IN OUR INHERITED ARTISTIC GIFTS;

AND ESPECIALLY TO MY WIFE SUSAN,
AND OUR SONS MATTHEW AND BRETT.
THEIR LOVE, INSPIRATION, ENCOURAGEMENT, SUPPORT
AND UNDERSTANDING HAVE BEEN LIFELONG AND TOTAL.
THEY ARE WHAT MAKE MY LIFE AND MY ART POSSIBLE.

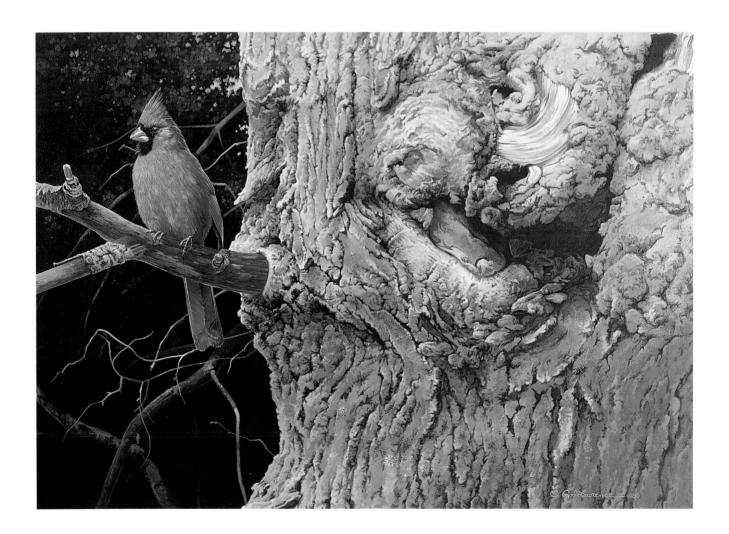

TABLE OF CONTENTS

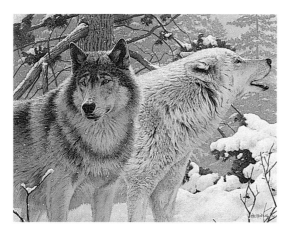

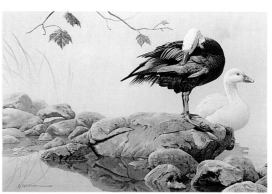

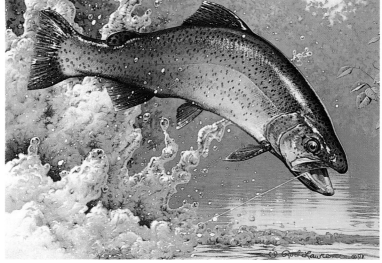

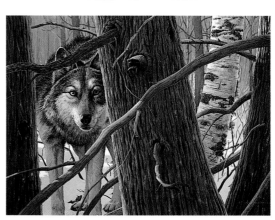

5

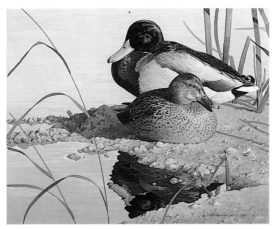

BILLS &
MUZZLES

6

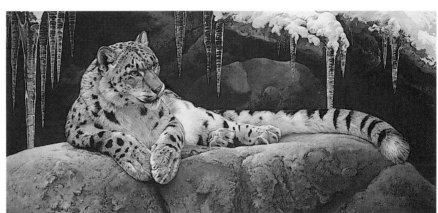

TAILS &
FEET

7

ANTLERS &
HORNS

8

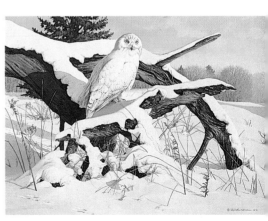

WHITE & BLACK
SUBJECTS

INTRODUCTION

This book is intended to be a helpful aid to wildlife artists. I have tried to convey all that I can in the confines of each page, to show how I approach painting different wildlife textures. While I have used several different kinds of paint for my demonstrations, I prefer acrylics and therefore used them for many of the paintings. Keep in mind that the painting examples are my approach and may not be how you would paint. Each artist has his, or her, own methods and these contribute to an artist's individual style. Thank heaven there is not just one correct way to paint!

I consider my painting style to be detailed and representational. However, that does not alter my appreciation of other forms of art. I encourage everyone that likes art to broaden their appreciation and education of art. There is much to be learned from art in all its rich and varied forms. Though not my style, I am constantly impressed and inspired by artists that paint in broad, loose styles. I love to read and study books on art; I learn a great deal from them and use them for inspiration. I hope that, regardless of your interest, as an artist or one that appreciates art, you will enjoy this book and find something of value to you. May it increase your interest in all art and the wildlife world that surrounds us.

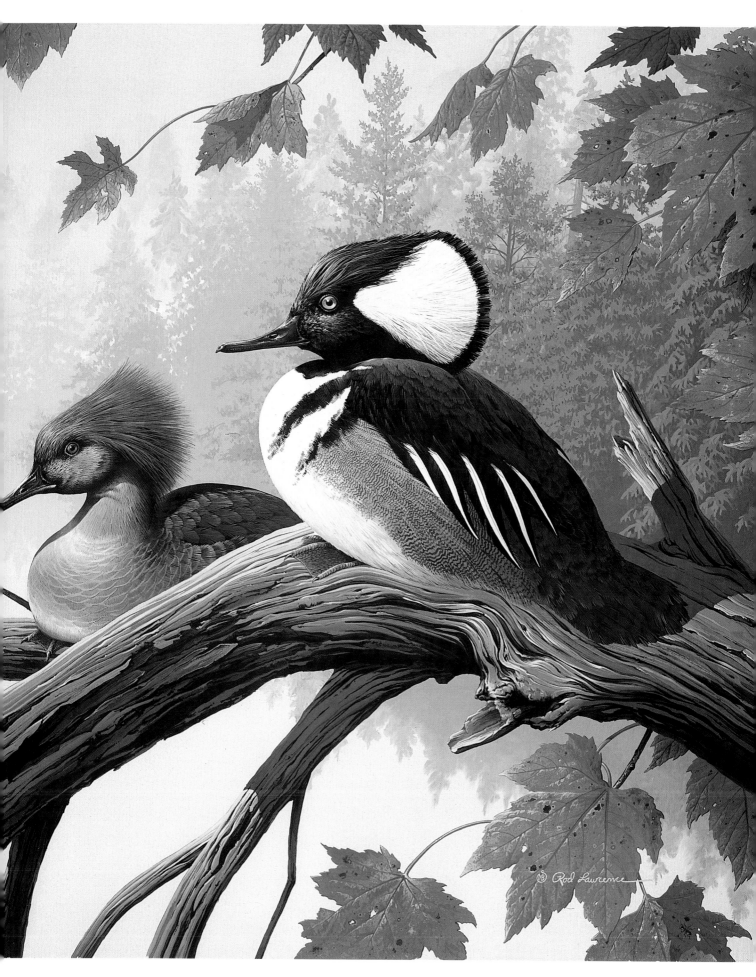

© Rod Lawrence

Materials

I believe in using the best materials for the best results. That does not necessarily mean using the most expensive, but simply the material or tool that will best achieve the results you want. This way of thinking encompasses all aspects of my artwork, from drawing and painting to the final step of matting and framing. Why limit your creative abilities by using materials that either make you work too hard or else curb your creativity because of their shortcomings? For example, if you need to paint a thin, precise line, why use an old, worn out brush that no longer holds a good point, when a new brush will make it so much easier and effortless? Let your materials help you create, not hinder the process. However, keep trying new ways to use your materials, the old and new ones. That is how you can find some exciting results and methods to build on.

PAINT

I suppose the best place to start when discussing painting materials is with the actual paint itself. In keeping with what I already said about the best material, the quality of your paint is very important. If you want your artwork to last, to pass the test of time, then you need to be sure that you are using materials that are tested and rated to do just that. I feel that if you are a professional selling your work, this is very important for both your work and its collectors. Most quality paints in most mediums are rated by the manufacturer in several categories. I use only those products rated at the top by the manufacturer and avoid all those that might be second-best or questionable. For example, the Winsor & Newton designers' gouache that I use is rated from "AA" to "C." Because of durability, I use only

those colors rated "AA" or "A" and mix those colors to obtain others. Look for paints that are durable and lightfast, so they will not fade out as readily during long exposure to light—such as when hanging on a collector's wall. Most of the better manufacturers will have a published rating guide you can refer to. I have done a fair amount of painting in oil and gouache, but have painted almost exclusively in acrylics for the past fourteen years. I like the fact that they are fast-drying and durable, and that they do not have to be framed under glass. On the following pages I will show demonstrations in acrylic, oil and watercolor.

SELECTING AND PREPARING SUPPORTS

The next most important material for your painting is the support. Supports include paper, illustration board, stretched fabric, or panels. These are available in a variety of qualities. Be sure to check out your painting support just as thoroughly as you do your paint. Most of my work is painted on a type of board panel that I prepare for painting myself. My preference is untempered, 1/4"-thick Masonite. Although this is now considered inferior to wooden panels as a permanent painting support, it is still widely used and accepted by artists— perhaps a holdover from past years when it was thought to be more suitable. I am searching for an alternate support for my work, but I am still currently using this type of board. It is available at your local lumberyard in 4' x 8' sheets that you can have cut small enough to transport to your studio. Once cut to size, thoroughly sand each side and smooth the sharp edges and corners. Then, apply a coat of acrylic gesso (either straight from the container or slightly thinned depending on

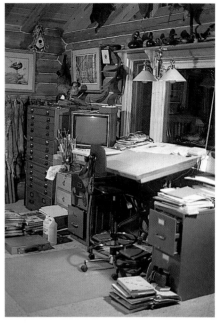

My painting area, with most of my materials kept handy on the left side of the table.

Many artists that attend my workshops are curious about the palette of colors that I use. Of course, if you have the primary colors you should be able to mix just about any color that you desire. However, it is quicker to have some premixed colors that you frequently use. So, for those who are curious, my color palette is as follows (in alphabetical order): Burnt Umber, Burnt Sienna, Cadmium-Barium Orange, Cadmium-Barium Red Medium, Cadmium-Barium Yellow Medium, Cerulean Blue, Payne's Gray, Permanent Green Light, Raw Sienna, Titanium White, Ultramarine Blue, Yellow Ochre Light and, occasionally, Cobalt Blue.

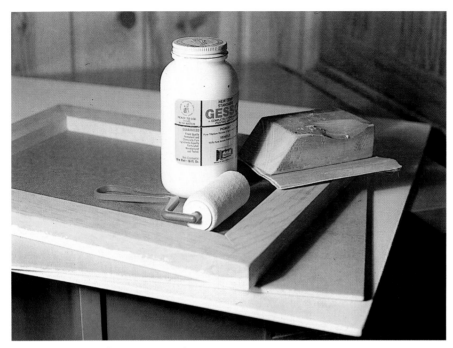

Painting supports being prepared.

your needs) to one side and all the edges. After that coat is completely dry, sand the surface and apply a second coat. Repeat this process as long as necessary: It seems to take three to six coats to establish a good ground. I prefer to apply the gesso with a small paint roller, occasionally using an electric hair dryer to immediately blow out the bubbles that may appear trapped in the wet gesso. The method in which you apply the gesso will determine the texture of the ground on which you will be painting. The way I do it seems to give me a slight "tooth" texture similar to cold-press paper. By the final sanding, all the blemishes should be gone and a nice, even-textured surface is ready for painting.

BRUSHES AND PAINTING TOOLS

Many artists use a wide variety of tools to apply their paint. Here, the quality of the tool is not so important, it is the results you obtain that matter most. Of course, picking out hairs from a bad brush while painting is not really enjoyable! I know of

some very successful wildlife artists that limit themselves to only one tool for painting, such as an airbrush, palette knife, or just brushes. I prefer a small variety, but do most of my painting with brushes. The brushes that I most commonly use are no. 2 and no. 3 rounds and a variety of flats and brights ranging in size from no. 4 to no. 8 and ³/₈" to ³/₄". I use some good quality sable brushes as well as some synthetic ones. I keep a large supply of both old and new brushes. Like most artists, I confess to stretching out the use of my old

favorite brushes much too long before giving in to the use of a new, easier-to-use one. Other items I occasionally use are sponges (both natural and synthetic), paper and cloth for dabbing paint, and my hands and fingers. Keep in mind that some products can be toxic; you should be careful handling them.

TIPS ON USING ACRYLICS

I use my acrylics in a relatively thin state, using only water to thin them. I use a disposable waterproof palette and squeeze small amounts of paint onto it. I keep these globs of paint moist with drops of water from an eyedropper. This way, I can mix paints on the palette as I work and keep the paint at a consistency that I like—about the consistency of runny toothpaste. I can then thin them even more while painting. If I need a quantity of paint for a larger area or larger painting, I put the paint into a plastic 35mm film container. They are relatively airtight and by adding a few drops of water now and then, I can keep the paint for quite an extended period. I also use many thin washes to build up areas of detail and find that I really enjoy this process of creating on my painting. On areas that are either large, or exceptionally dark or light, it will take quite a number of washes to build them up.

Brushes I use most commonly on my paintings.

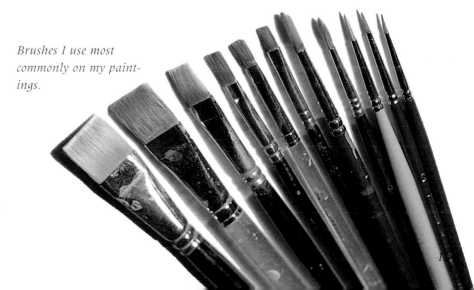

Painting Methods

WATERCOLOR, GOUACHE, OIL & ACRYLIC

Most types of paint can be used to produce similar results. If I want to achieve a certain look for a particular painting, I should be able to do that regardless of the type of medium I decide to use. However, each medium has its own unique characteristics. While they can be manipulated to produce similar effects, that does not mean that effect reflects the best use

of that particular medium. For example, a loose watercolor flow on wet paper is an effect that would be difficult to duplicate in oil, and is best done in watercolor. Imagine what a thick impasto-style oil painting would look like if you tried to duplicate it in watercolor.

As you can see, the final results with these four different paint mediums are very similar. It can be fun to try to achieve similar results with different paints like this. On the other hand, it can also be fun

to let the paint show you what it can do and express yourself through its character. Try both; have some fun experimenting, and you will learn the properties of the paint.

My style of painting adapts well to several different mediums. I must always be aware of the medium I am using and its limitations. This means I will approach the painting differently, but the final effect can be similar if that is what I am trying to achieve.

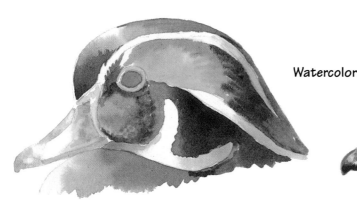

Watercolor

Start

With watercolor, I start with light washes. I wet the paper in the area I am working on to control the flow of pigment.

Finish

Over the basic layout of light and dark color values, I build my painting with increasingly darker values. I moisten and blot key areas of light such as the eye and bill tip.

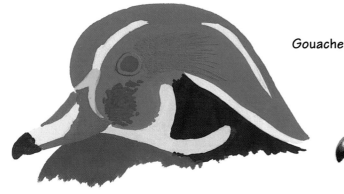

Gouache

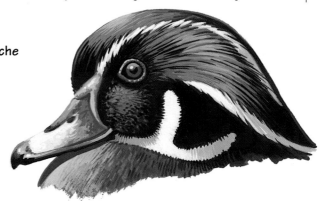

Start

For gouache, I use opaque paint of medium values to lay in the shapes. You can see the paint looks flat but bright in color.

Finish

I then work in both lighter and darker values to create the form and shadows. Gouache is so opaque that I can work back and forth from light to dark with just one stroke of paint rather than the several layers I need for watercolor or acrylic.

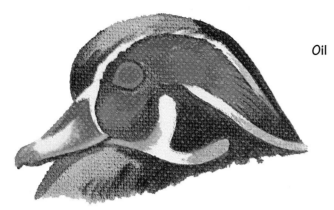

Oil

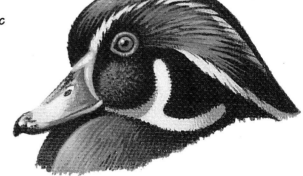

Start

I start my oil painting with a simple underpainting using only Burnt Umber. Over this I apply my first colors.

Finish

I then use middle values of color and add darker and darker values. I generally use the lighter values in later steps. This is done entirely with a wet-on-wet technique.

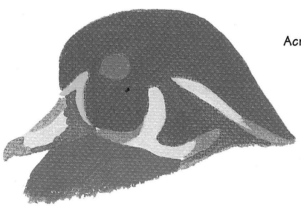

Acrylic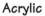

Start

A base coat of acrylic colors, in medium values, is my starting place, as shown here. It will take several coats of paint to build this up.

Finish

With both darker and lighter values of color, I build my forms and shadows. I use subtle washes as well as several more opaque applications of paint.

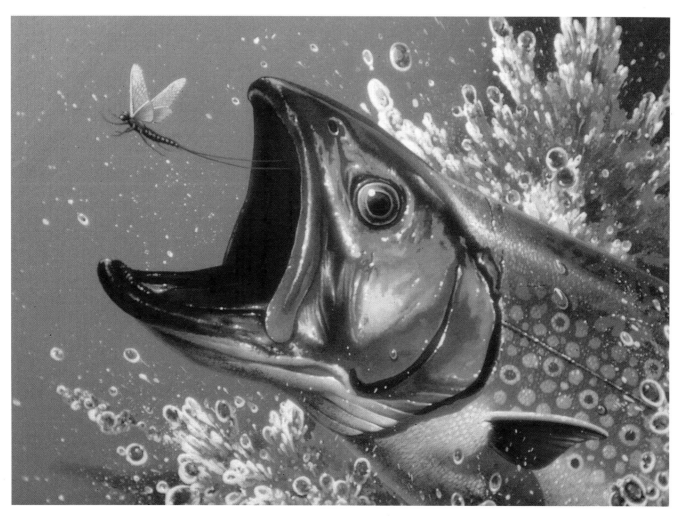

1981 MICHIGAN
TROUT STAMP
(*Brook Trout*)
Gouache, 5" x 7"
Private collection

SPLATTER

I occasionally use sponges and splattering techniques in my work. I am careful not to overuse them; I do not want the application of the paint to take away from the focus of the painting.

The painting above is a good example of splatter technique. Most of the water splashes were painted first and then the painting was finished. Then I cut a mask for the fish (a piece of paper in the shape of the fish) to protect that area. To create the splatter, I dipped an old, dry bristle brush into my mixture of thin white paint. Holding that brush over my painting, I dragged the brush across the edge of a scrap piece of mat board in the direction I wanted the splatter to go. The mat board causes the bristles to spring forward and splatter the paint. Some of the paint I allow to dry, some of it I blot with a tissue to get a softer effect. I also went back with a small round sable and painted a few drops where I thought it necessary.

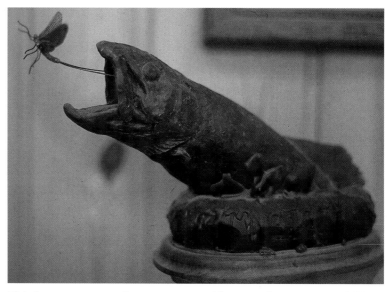

This is a wax trout sculpture I was working on using my 1981 Michigan Trout Stamp painting as reference.

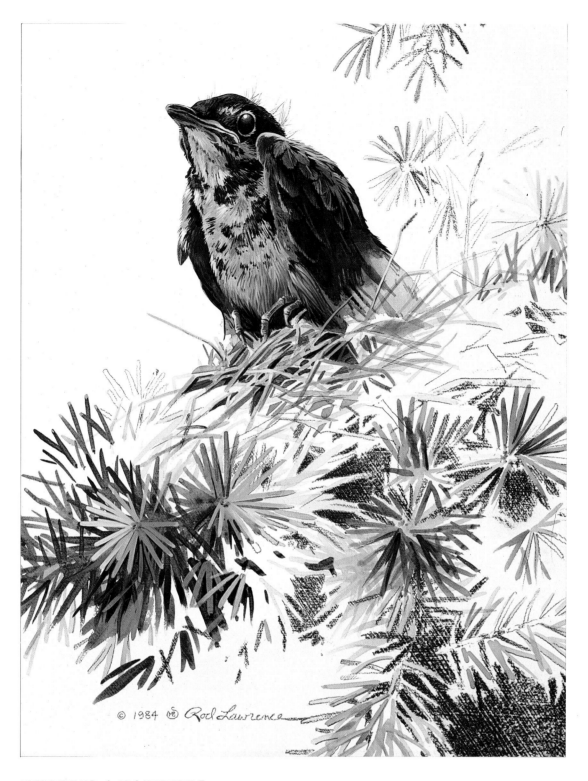

WHEN IS A PAINTING FINISHED?

At what point do you stop and decide, this is it, the painting is finished? It is not an easy question to answer and obviously each artist must make the final decision. This painting of a robin fledgling is interesting to me. I started with every intention of doing a complete, "finished" painting.

When the painting reached the stage shown here, several things occurred to me. This robin is the last of its brood to leave the nest. His life is just beginning and he is not yet "finished." It seemed appropriate to leave the painting in this same state, to echo the robin's unfinished stage.

Reference Material

People often ask me what I use for reference when painting wildlife. I use anything and everything! There are so many types of wildlife as well as a multitude of habitats that I cannot imagine retaining all that information in my mind. Reference material is great for stimulating your memory, learning, inspiring, and—most importantly—painting from.

LIVE ANIMALS

For wildlife painting, the obvious choice for reference is actual wildlife. Depending on the subject matter, I look for this type of reference in the wild, in zoos, or even people's pets. The national parks, such as Yellowstone in Wyoming, are wonderful for observing and photographing wildlife. However, I am amazed at the amount of accessible wildlife right around me. With a little food for bait, such as seed for birds or corn and hay for deer, I can entice a variety of wild creatures to venture into my camera range. As I look around and talk to people, I find there are many animals in my community and nearby parks. There are more and more people who rehabilitate wildlife, both birds and animals. They welcome the interest of an artist and they are excellent sources for reference material. I have started to keep a list of people and places that have wildlife subjects I can use as reference.

TAXIDERMY

Taxidermy mounts and study skins can be very helpful, but you must know what you are looking at and what is correct. Unless the taxidermist is an expert, you must be very careful relying on the anatomy of a mount to be correct. I have seen many paintings of wildlife copied

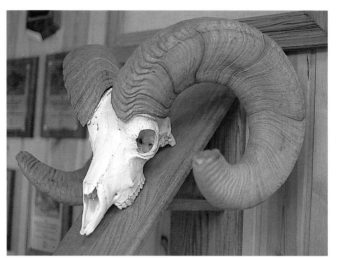

This is a record-book bighorn sheep skull I found on one of my photographic reference trips. I have found painting from it very useful.

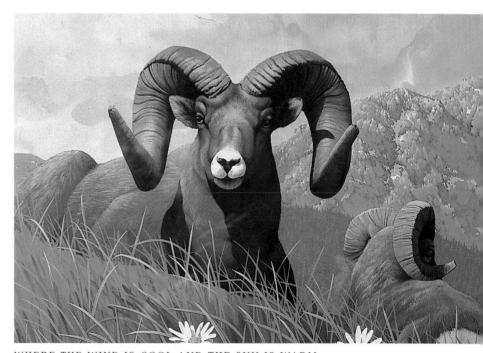

WHERE THE WIND IS COOL AND THE SUN IS WARM
(Bighorn Sheep) Gouache, 16" x 24" (Detail), Private collection

The large bighorn sheep skull I found proved to be an excellent reference for this painting. I felt like I was bringing this magnificent animal back to life.

so faithfully from a mount that the creature in the painting looks just like that—not real wildlife, but a badly mounted specimen. The bills and beaks of birds may be improperly painted by the taxidermist or have faded from their true color. The best use for this type of reference is the study of details and patterns of fur and feathers.

CARVINGS AND MODELS

I also use various kinds of decoys for my reference. Duck carvings and decoys can be placed in water to

study reflections and ripples. The newer three-dimensional deer archery targets are wonderful for putting in a likely setting and checking for light, shadow and scale. Making your own models of clay or paper can also be very helpful and I do that on occasion as well.

USING PHOTOGRAPHY

The use of a camera and photographs is very helpful for reference, but you must be cautious and use this information carefully. Photographs tend to flatten planes and distort perspective. You need to have a good working knowledge of the wildlife you are portraying in order to interpret photographs correctly. I take many photographs to help me in my paintings and file them for later use. I also have what I call a "swipe file" of photographs that I have torn out of magazines. These are filed according to subject matter and then broken down further if necessary. For example, I have a series of files on waterfowl, broken down into ducks, geese, and shore birds. These are further broken down in each subject by species. While these published photographs should not be copied (unless you have purchased them or have permission from the photographer), they are extremely useful for ideas, details and color. I have been collecting and sorting my swipe file for more than twenty-five years. In recent years, reference videotapes, as well as slides and photographs from professional photographers, have been offered for sale.

While working on a painting, I may use over one hundred photos for reference; I usually build a file just for that painting. In addition, I'll use whatever skins, mounts and other references I can find.

Keep in mind that if you have a good understanding of the wildlife you are portraying, the reference items that you use do not have to be perfect. I certainly am not a profes-

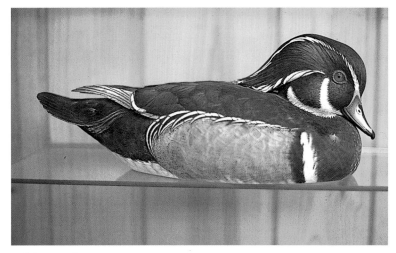

WOOD DUCK
Painted wood carving by Clark Sullivan, Collection of Rod Lawrence

Although this carving was done from my painting, I have since used the carving for reference for other duck paintings.

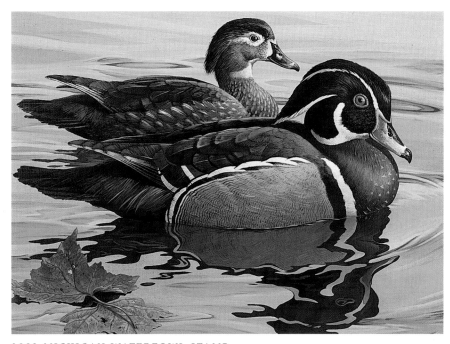

1983 MICHIGAN WATERFOWL STAMP
(Wood Duck) Acrylic, 7" x 9 1/4", Collection of the artist

sional-class photographer, but I can shoot pictures that are good enough for my own reference. I have purchased some garage sale reference mounts for as little as fifty cents. They may not be the best, but I find them great for ideas and some details. Beautifully carved decorative duck decoys and cheap plastic hunting decoys can be helpful in planning a nice waterfowl painting.

My feeling is, if you have insufficient reference and you are struggling to paint an animal because you are unsure just what it looks like, your painting will reflect that. We paint what we know best. Get to know the wildlife subjects that you plan to paint. Learning and studying wildlife is one of the really fun aspects of being a wildlife artist.

My Approach

I usually start my slide show lectures with photos of my studio. I think it is very interesting and important to see where an artist works and what he has around him. Even the location of his studio can be interesting and inspirational.

MY STUDIO

I am very fortunate in having a studio that is conducive to all my needs. I live in northern lower Michigan, basically in the woods. My studio borders a small cedar swamp mixed with hardwood. A nice little trout stream flows in full view right through it. From my studio windows, I can see much of the wildlife of my area as it passes by throughout the year. I keep my studio full of wildlife-related items that serve as reference and inspiration. I always seem to find something to add to my studio, so it has become crammed with mounts, skins, skulls, antlers, decoys and anything else that sparks my interest. I keep my studio divided into several smaller areas for business, display, reference and actual painting. I use a drafting table set with a slight slope for most of my work. On the larger pieces that I cannot reach around, I use a large easel.

LIGHTING

While I use a lot of natural light (from studio windows and skylights), I almost always use a source of supplemental lighting—usually several strong incandescent bulbs. Despite all the fuss about using north light and controversy over what is proper lighting, my main concern is having lots of light to see and paint with. I do use some color-corrected bulbs, but most paintings are viewed in the home of a collector by natural light and typical incandescent bulbs. It could

This is my studio as seen from the creek looking up the bank.

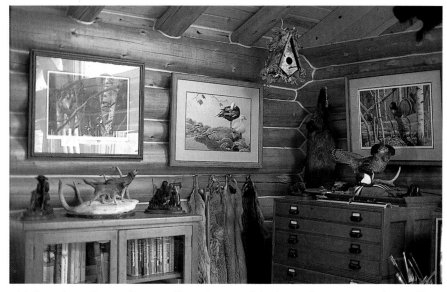

This is a view of part of my studio and some of the items that I surround myself with for inspiration and reference.

be argued that it might be best to paint the picture under that same type of light.

SKETCHING IDEAS

Almost all of my ideas, and therefore the start of all of my paintings, begin in my sketchbooks. These initial ideas start as very small "thumbnail" size sketches. With these I can make quick idea changes, usually in pencil, and alter the composition or any number of other aspects of the original idea. The sketches that I really like and feel have potential, I continue to

rework and expand. Once I've selected one for a painting, I enlarge the sketch and usually do a full-size layout drawing. This helps me to understand the composition I have developed as well as the wildlife that will be painted. This is the stage when all the references come into play and help me to make sure the pose that I have chosen is correct and can be painted with some authority.

Here are thumbnail sketches from one of my sketchbooks. The darker, more developed ones are those that I felt had potential as a painting.

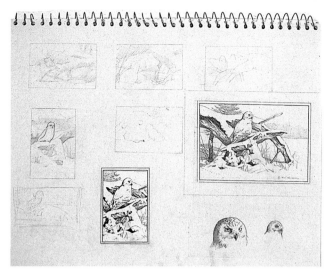

TRANSFERRING THE DRAWING

The next step is to make what I call a transfer sheet. I place a sheet of tracing paper over my layout drawing and make a tracing of the simple basic lines of the design. Tracing paper is great for working on design changes and altering the position and pose of elements in your layout.

When I am satisfied with the tracing transfer sheet, I use a 2B or softer pencil and retrace each line on the back of the sheet. I place the transfer sheet over my painting, and with a hard pencil such as a 4H, I go over the lines and transfer my drawing to the exact spot that my design calls for. This is most helpful when I have painted over areas and need to reestablish where a particular item must go. Of course I am not bound by this, and usually make changes as I paint when they seem necessary. It does give me a good plan to go by and eliminates the struggle of getting things right from the start.

This is a full-size layout drawing with the transfer sheet (overlapping) completed.

PAINTING

After my painting support is prepared (usually a panel as I described earlier), I begin the painting by laying in some initial colors to be used in the background. Sometimes I paint around my main subject matter, leaving it white. Other times I lay a rough color in on all the elements and then concentrate on

one area. I usually finish the background first, then the main subject and finally the foreground. That is not necessarily the right way, it is just my approach. When my painting is finished, if it is acrylic, the final step is to apply a protective finish. The same care should be taken to protect paintings in any medium as required for that medium. My preference is a spray can of gloss finish. It can be removed with turpentine without harming the acrylic paint underneath. With this method, smoke damage, surface scratches and dirt can be removed and a new finish applied.

FRAMING

At this point, let me add a few words concerning framing. Take the time and care to have your work properly matted and framed. Proper framing is important from a conservation standpoint, but more significant is the effect it has on your artwork. How your work is presented can say a great deal about you and how you feel about your work. Good framing becomes a part of the total art piece and can add considerably to the overall impact of the painting. Learn to do it correctly or have a professional framer handle your picture framing.

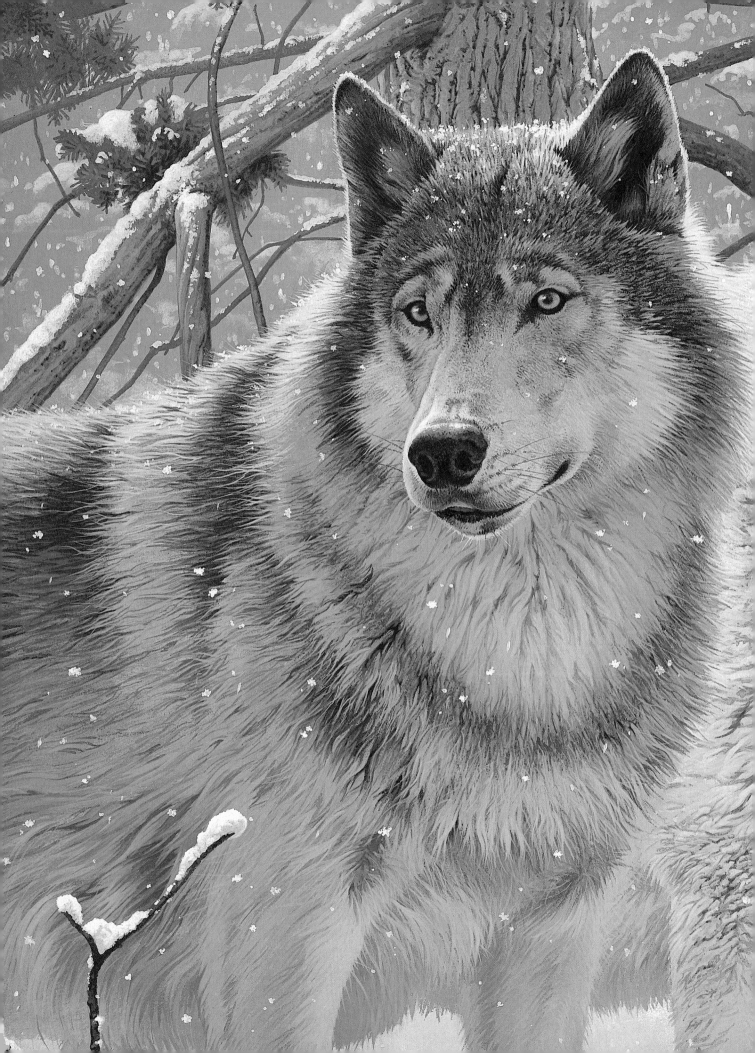

1

FUR

BREATH OF WINTER
(Gray Wolf) Acrylic, 18" x 27", Collection of Don and Lynda Lewis

FUR can be defined simply as the hairy coat grown by mammals. It provides many major functions for these animals. This covering of hair keeps some animals warm under harsh, cold conditions by acting as natural insulation. Yet it helps others stay cool in extremely hot climates. Fur can keep some animals waterproof and buoyant, and aid in the drying process by shedding water. It offers some protection from insects and brush, and serves as camouflage from predators through the use of color and pattern. Fur color and composition can even change with the seasons to help the animal adjust more comfortably to seasonal environmental changes.

The variety of fur is just as fascinating as its functions. There are so many types of hair—thick and thin, long and short, curly and straight. The colors and patterns are richly varied.

All these characteristics can be quite a challenge to the wildlife artist. You must consider not only the animal you are painting but also the different types of hair found on different areas of its body. Consideration must also be given to the time of the year your picture is portraying and sometimes even the age of the animal. Many young animals have spotted coats that change as they get older. On many species, long winter fur is shed each spring and a short summer coat is grown in its place.

Modified Fur

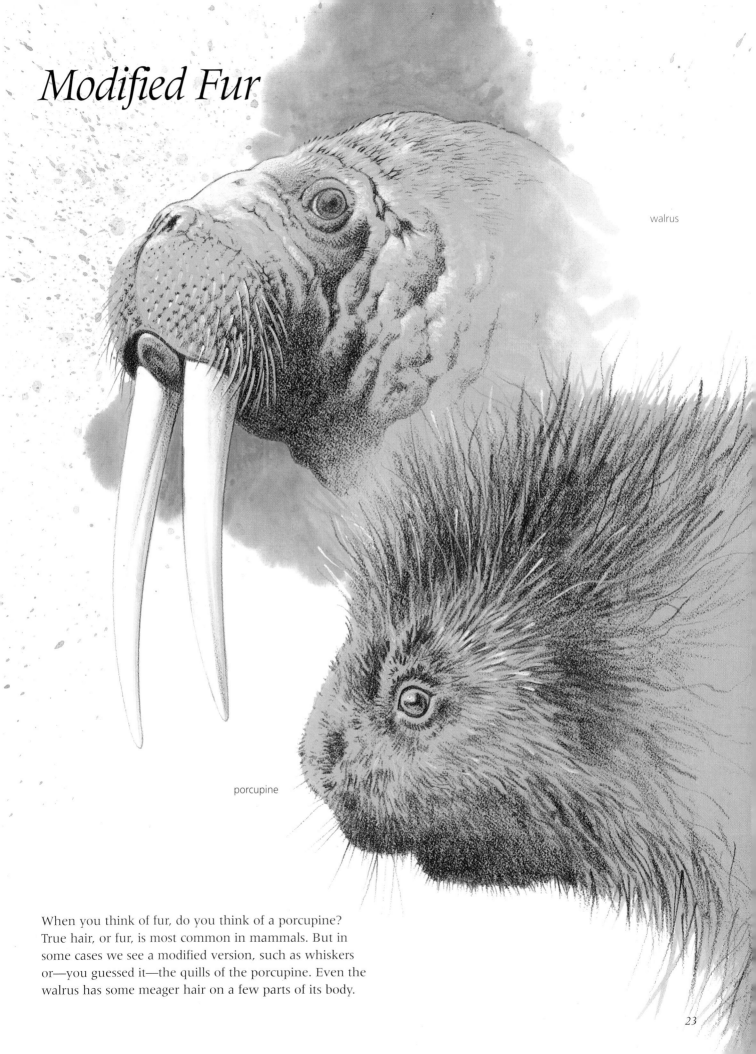

walrus

porcupine

When you think of fur, do you think of a porcupine? True hair, or fur, is most common in mammals. But in some cases we see a modified version, such as whiskers or—you guessed it—the quills of the porcupine. Even the walrus has some meager hair on a few parts of its body.

Long Fur

AMERICAN ELK

(Acrylic)

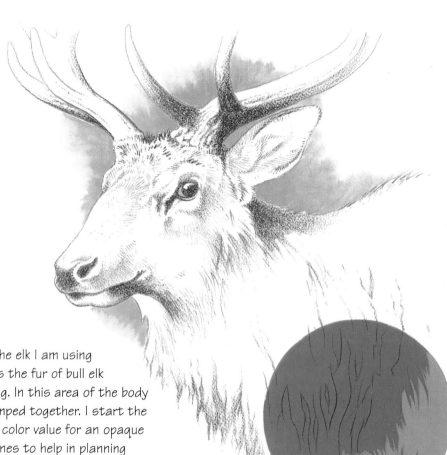

Step 1

The circle shows the area of the elk I am using for this demonstration. This is the fur of bull elk in late fall when the hair is long. In this area of the body it is sometimes thick and clumped together. I start the painting with my usual middle color value for an opaque base. Then I use some pencil lines to help in planning the basic fur structure.

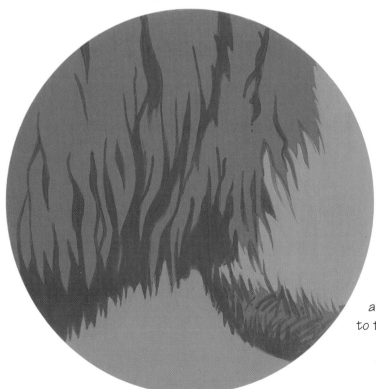

Step 2

Add shapes in a slightly darker color value, using your pencil as a guide. These darker areas contrast with the base color, allowing shadows and clumps of fur to show up nicely without being too strong yet. Major fur areas are now defined according to the elk's anatomy.

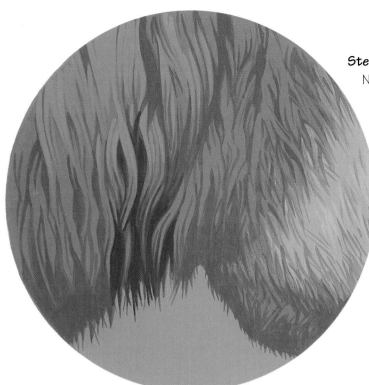

Step 3

Now, use subtle contrast changes to add more detail and further define the long strands of hair. Add both some lighter tones and small areas of darks. These changes in value are what create the look of the fur texture. As you paint, keep thinking of how long hair tangles together and try to convey that in the painting.

Step 4

The last values of lightest lights and darkest darks are applied to the overall fur pattern. The dark values help pull you into the shadow depths. The light values should bring the high-lighted fur out of the picture. This should achieve the three-dimensional look of long fur. The fur strokes in the lighter area stay subtle to keep that area light in values.

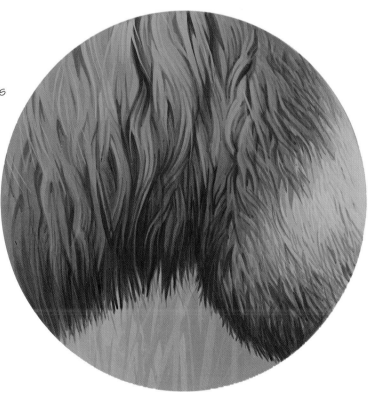

Short Fur

BOBCAT
(Acrylic)

Step 1

For this bobcat head, start with a tan base color and then add three other colors: a light gray, a darker bluish color and a dark value of Burnt Umber and Ultramarine Blue with some Cadmium-Barium Red Deep. The tan and grays represent the middle values; the darkest value here is one step away, on my imaginary value scale, from my final darkest value. Refer to a paint swatch to make sure that there is a clear distinction in values, so they will play off each other in contrast. It will take several more coats of the dark mixture to build it up to a solid value where necessary. Use this dark value with varying amounts of water to make thin washes. You can "draw" with these to lay in the dark areas and start painting hair details.

Step 2

Add more details with the dark paint mixture to make some areas, such as the eyes, ears, nose and mouth, more opaque using several coats of paint. Add Cadmium-Barium Red Deep and Yellow Ochre Light to the dark mixture and thin with water to paint hair and suggest more details, starting around the eyes. For this area of short fur on the head, use a lot of short strokes, even to paint the shapes that appear to be long, dark lines on the forehead. These may be formed by the fur pattern or by head structure, but keep the strokes short and broken, like the short hairs will be. At this point, establish a base color value on the nose and in the eye.

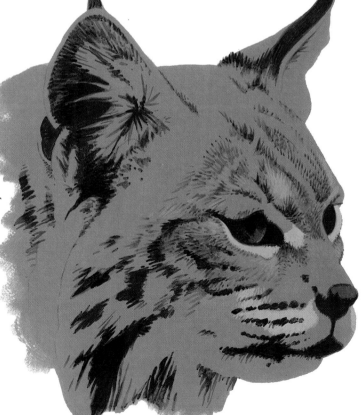

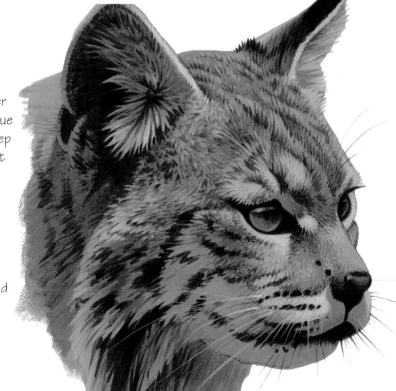

Step 3

Continue the process of suggesting hair and details, but now add a similar process with the light areas of the fur. Try mixing Cerulean Blue, Ultramarine Blue, Cadmium-Barium Red Deep and white to your base tan color. You are looking for a slightly lighter value than the base color. It represents the overhead light reflecting off the fur on the upper surface of the head and should have an almost lavender look. Use the same short strokes to suggest this light on the fur. You can work these areas of light and dark back and forth, refining and detailing as much as you want. This is when the painting starts to look more three-dimensional.

Step 4

Make your "lavender" light paint another step lighter by adding white and continue fine-tuning the fur in short strokes. Keep enough color in the mixture so it will not result in a "chalky" look. For the white areas around the eyes and muzzle, add white and a touch of Cadmium Yellow Medium. Mix Burnt Umber, Ultramarine Blue and a little Cadmium Barium Red Deep to make a final dark paint which accents the eyes, ears, nose, mouth and a few of the dark spots of fur. Add the whiskers last, using a brush with a sharp tip.

Curly Fur

AMERICAN BISON

(Watercolor)

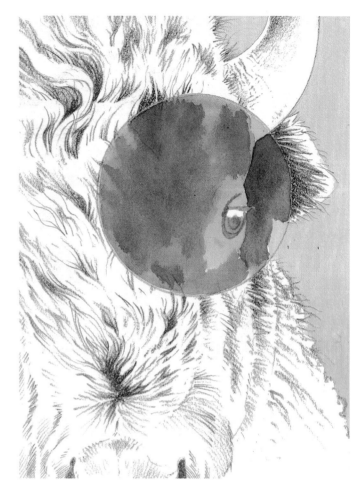

Step 1

For bison fur, start with a few color washes of light to medium values. These help establish preliminary color areas. Begin by premixing the colors you intend to use on this step, then wet the area so the colors will flow in a wet-on-wet technique. With your layout drawing on tracing paper, you can transfer some key lines back over the painting when it is dry.

Step 2

Use the transferred pencil lines to guide you in applying some deeper colors to define the hair shapes. Slowly build contrast to show form and depth. This step is a good start toward that end and helps you understand the fur areas better as you paint. When working with watercolor, always try to keep the light areas from getting too dark too soon.

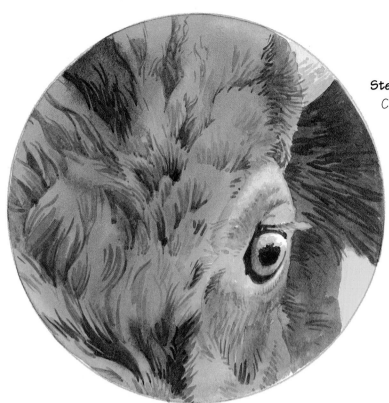

Step 3

Continue adding more dark values to build forms. Details can be added and the contrasts between light and shadow become stronger. Subtle color washes are used to insert color changes where they are needed. These areas will be reworked in the last step.

Step 4

The final phase is often the fun phase. Now you can add the final details. The addition of the final darkest values really brings out the forms and ties the painting together. You can still wet and blot areas to lighten them if necessary.

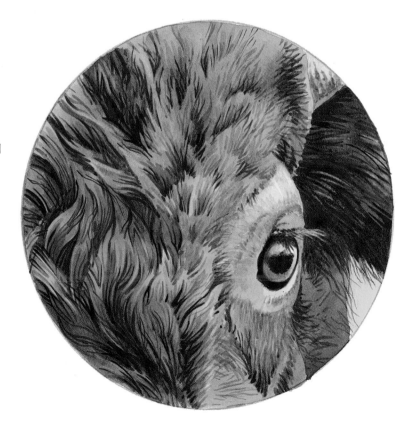

Painting Fur Patterns

SNOW LEOPARD CUB

(Acrylic)

Step 1

To paint most fur patterns, start with a flat, opaque background of medium-value color. Using a transfer sheet, put the major lines for the fur pattern from your layout drawing onto the dry paint. Using a somewhat worn no. 2 round brush, begin painting some fur markings according to your drawing and reference material. Use paint that is the consistency of runny toothpaste or even thinner.

Always keep in mind the texture you are painting—in this case, the short, dense fur of a cold-weather mammal, a very young snow leopard cub. Thin washes of either dark or light values can create interesting areas of semi-transparent paint. Later, these can be accented to look like small clumps of fur.

Step 2

In addition to the larger dark pattern areas, now begin to add the small shadows in the lighter fur clumps. This is not a really dark value contrast, but enough contrast to show up well. Then take a lighter value color and begin to paint the lighter areas of fur. Paint this lighter tone mainly on the upper portion to indicate light striking the higher and more prominent areas of fur.

Step 3

Now mix up both darker and lighter color values. With these mixtures you can put in more detail and continue to build the illusion of depth and put more emphasis on light and shadow. At this time also use some thin washes to lighten small areas of fur in the middle of the dark fur spots. By now, you should be able to tell which areas are working well for you and which areas you need to work on to get a better fur "feeling."

Step 4

Time to make the fur really stand out. To get the feeling of depth, use your final dark and light to play up the shadows and highlights, adding yet another layer of value changes. This layering is the secret to creating the "fluffy" feel of fur. You can also put in a few individual hairs to further enhance the texture. If you are successful, the completed painting has the look, and to the viewer's eye has the "feel" of the young snow leopard's thick fur.

Painting Wolf Fur
(Acrylic)

Step 1

The background of this painting is completed first, knowing you may make some changes on it later, after you have finished the wolf. To start on the wolf, you want an opaque-looking paint base in the color that will be predominant throughout the wolf's body. Mix this base color, keeping it to a middle value, relative to the range of values you use. Use paint about the consistency of runny toothpaste and, with a ³/₈" bright sable brush, build up several layers. While this is not a totally solid color, it is very close and the paint strokes showing through may help in suggesting fur texture. This step reestablishes the wolf's position over the background work. Paint the edges of the wolf's outline and use a fine-tipped no. 3 round sable to show individual hairs. It helps to begin making a ragged, furry edge to the outline of the wolf right from this start, even though it is only a tan silhouette at this point.

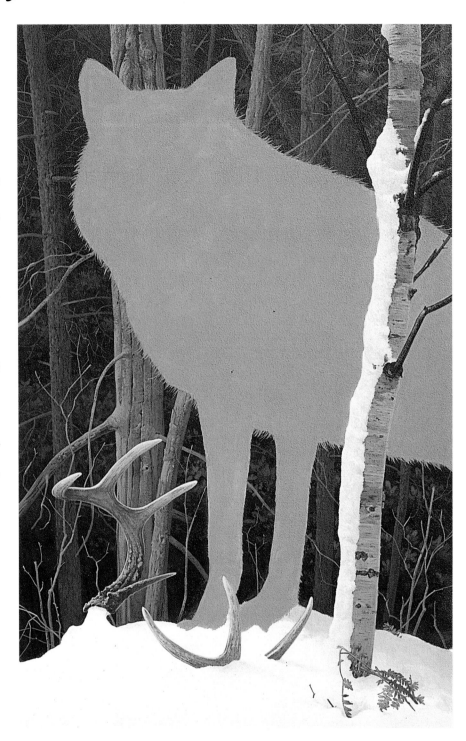

far right

Step 2

Using your transfer sheet from the original full-size layout drawing, transfer the major features of the wolf to your painting. These include the facial features and some major fur areas, such as the location of the fur cape on the neck and the fur around the face. Mix a color that is the next darker value, a brown/gray color, and use this thin paint to "draw" over the base color to indicate the shadows, major fur clumps and dark areas such as the eyes and nose. This is an underpainting of sorts; some of it will show through later washes and some of it will be painted over. It helps you plan how and where you are going to paint the fur texture. It also serves as a guide for applying paint as you progress.

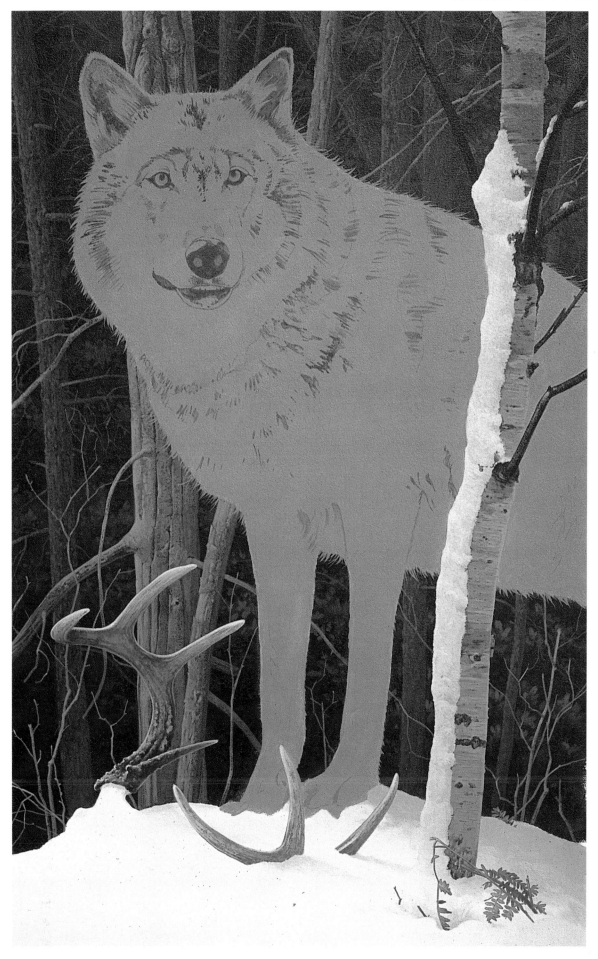

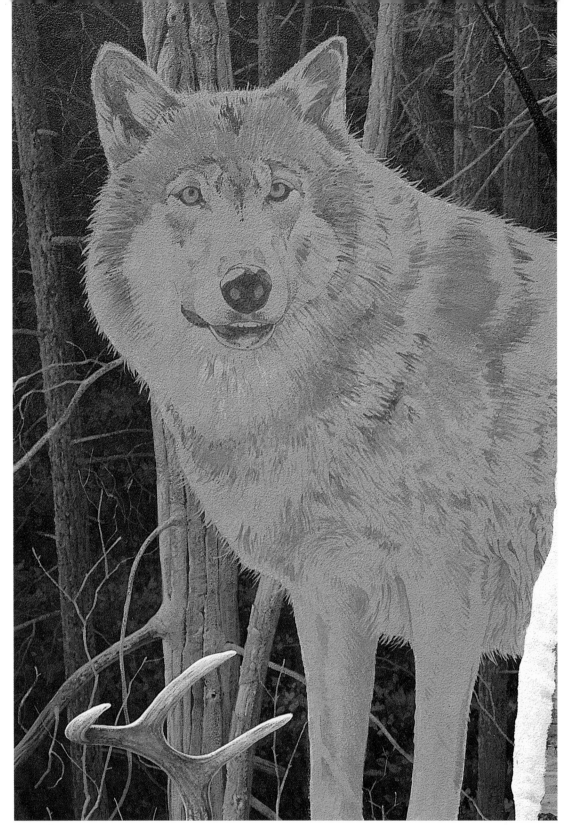

Step 3

Here is a closer view of the wolf, using several different colors, each still close in value when compared to the middle value of the tan base. Slowly build on the textures and details. Some of this paint is applied as a wash and some as a single brushstroke of thicker paint. After some of the other colors are applied, start using an even darker value of paint around the muzzle area. Notice that in comparing the value of this color to the dark values in the background, you are still several steps away from a very dark paint.

It is very important to keep in mind where the short and long hair is located on the wolf. As you paint the fur, your brushstrokes and details have to be consistent with the length of hair in the area that you are working. Keep checking your reference and "think fur" as you work.

Step 4

Continue to add both washes and brushstrokes of increasingly darker values, concentrating on the areas on the wolf that will be the darkest. On the upper section of the wolf's head, you can see where to use some gray paint that is almost the same value as the original base paint. This brow area has now been built up to near completion. Overall, you still have several steps to go until you use your darkest paint, and there are many areas of base color that have very little work on them yet. These areas will be painted in the opposite value direction, using progressively lighter and lighter colors, rather than darker and darker.

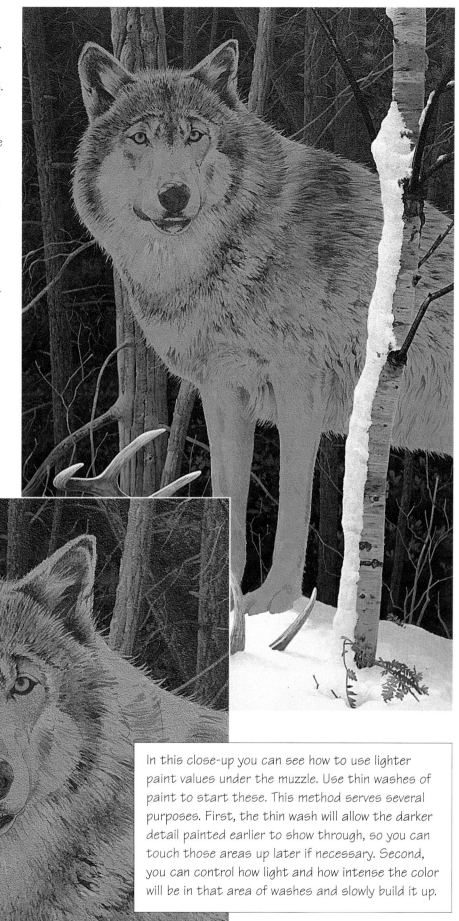

In this close-up you can see how to use lighter paint values under the muzzle. Use thin washes of paint to start these. This method serves several purposes. First, the thin wash will allow the darker detail painted earlier to show through, so you can touch those areas up later if necessary. Second, you can control how light and how intense the color will be in that area of washes and slowly build it up.

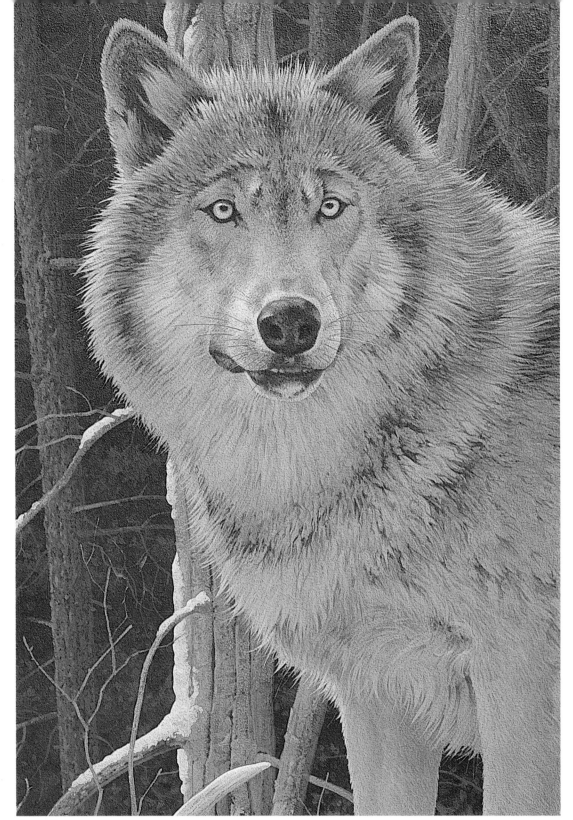

Step 5

From Step Four to Step Five, a lot is accomplished. For me, the fun here is that these lighter colors now begin to emphasize the general form and the areas of texture. The process that began with a flat base color, moving to the darker "drawing" stage, now moves into creating a more three-dimensional look. The texture gets to the place where your eyes and imagination can start to "feel" it. Work back and forth between all the colors and values to make necessary adjustments to the painting. The final step is to add the really dark values, especially in the eyes and muzzle. These are darker than anything in the background, so they will give better contrast and help bring the wolf's features forward to the viewer. The same thing is true of the lightest values. After doing most of the work with the other color values, these two extremes on the value scale are used to make the final impact and enhance the fur.

KING OF THE
FOREST
(Gray Wolf)
Acrylic
15" x 24 1/2"
Collection of the artist

2
FEATHERS

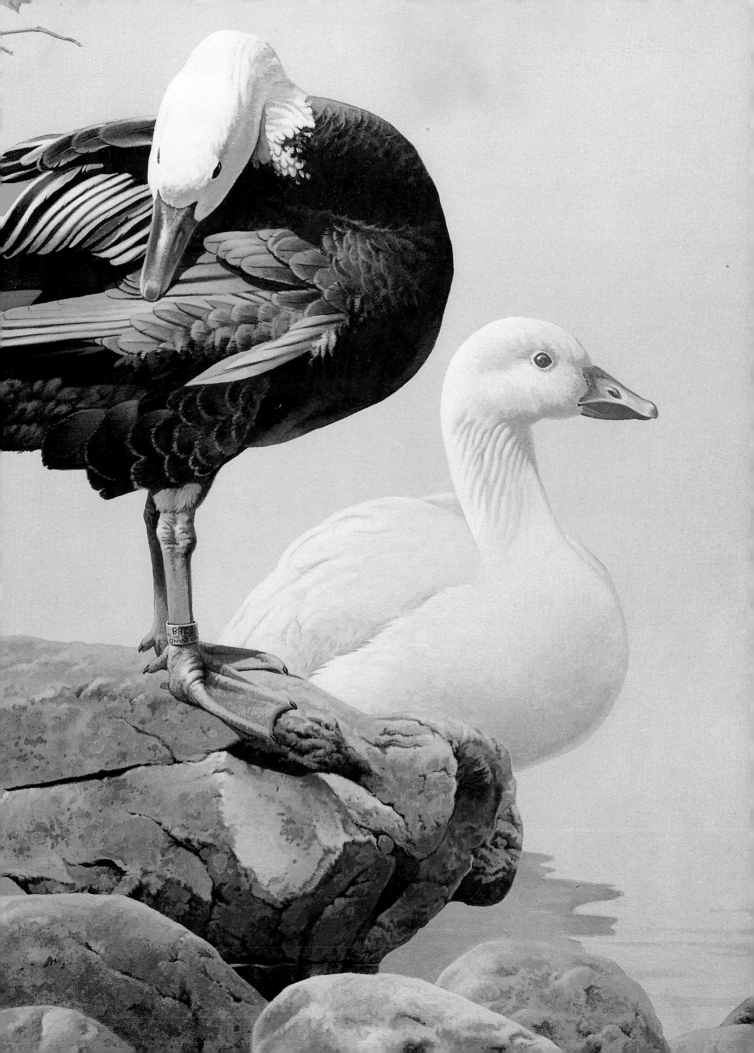

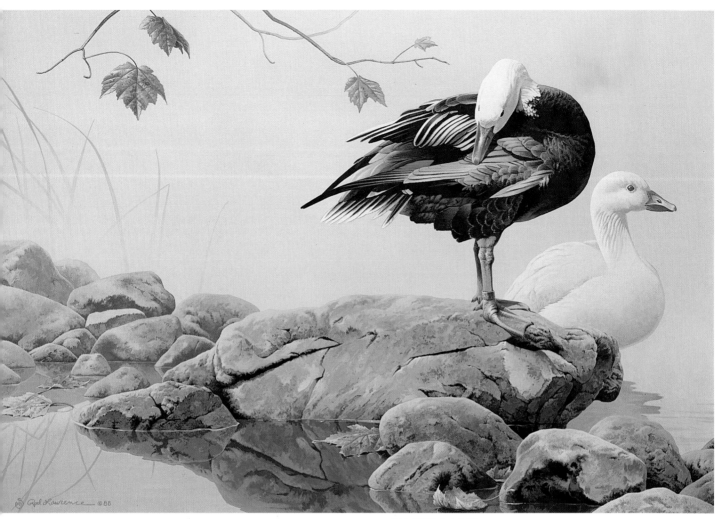

ON THE ROCKS
(Snow Geese) Acrylic, 14" x 21", Collection of the artist

FEATHERS are to birds as fur is to mammals. They

are the bird's protective covering and they must serve
many functions, including facilitating flight for most
species. From steaming hot tropical climates to frigid
arctic conditions, these feathers enable the birds to
survive in their environment. Most of us are familiar
with how effective down feathers are as insulation.
Feathers must develop at each stage of a bird's life to
protect it as it grows. Different feather shapes and struc-
tures have different functions. Flight feathers are very
different from down feathers. Because of the wear and
tear they suffer, feathers are replaced annually by a
process generally called molting. Many waterfowl

species lose all their flight feathers during the molt and
are incapable of flying until the new feathers are grown.

Painting feathers can be difficult at times—there
are so many shapes, sizes, colors and markings to
contend with. It is easy to get so caught up in the
pattern of a bird's feathers, like a ring-necked pheasant
or ruffed grouse, that the final painting of the bird
looks like a flat design. I know. I have painted my
share of flying tapestries, with interesting patterns,
that were supposed to look like three-dimensional
birds! It is vital when painting feathered wildlife to
maintain the form and think in terms of light and
shadow. Remember that feathers are a covering
over the anatomy of the creature.

This is an example of how great the size difference can be between flight feathers. Compare the life-size flight feathers of the humming bird to the life-size primary feathers of the golden eagle.

Wing Feathers

WOOD DUCK
(Acrylic)

This is the underside view of the left wing of a female wood duck. The illustration is life size.

Step 1

I start with two base colors. One is a medium value representing the general color of the wing lining next to, and including, the primary and secondary feathers. The second is a lighter and grayer color, representing the feathers located closer to the leading edge. These have the small brown spots on them. Each of these bases takes about three to four coats of paint to build up. Next, take your transfer sheet and trace the major feathers over the painting. (I use three brushes on the entire illustration: A sharp-tipped no. 2 round sable, a ¼" flat sable, and an old, worn no. 3 round sable. The last brush works great for doing the subtle washes.) With a slightly darker value outline the feathers, put in a few shadows and feather breaks and suggest a few of the spots.

Step 2

This step is shown on the lower half of the wing. With a darker value begin to indicate more feather details and darken the shadows. Paint some of the spots darker and suggest the smaller feathers and spots. Mix a lighter value for each area and use washes to show where the light strikes the feathers.

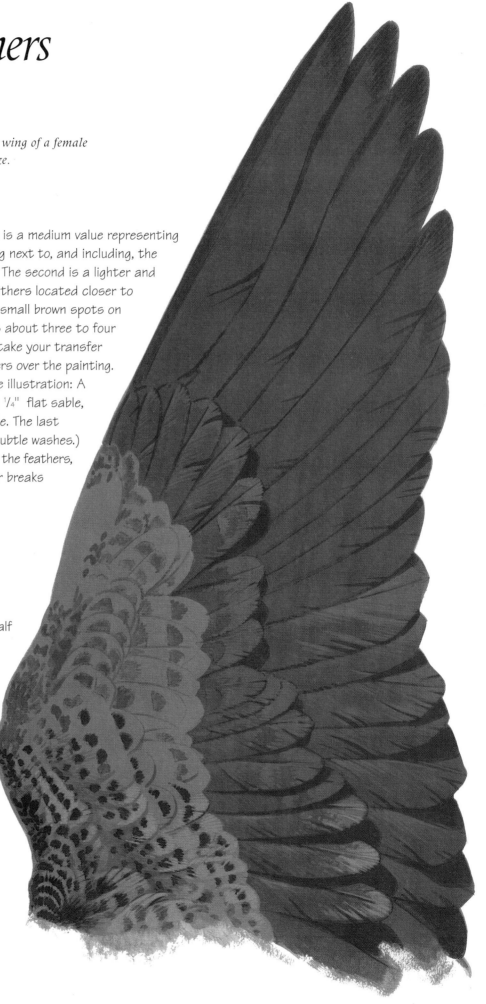

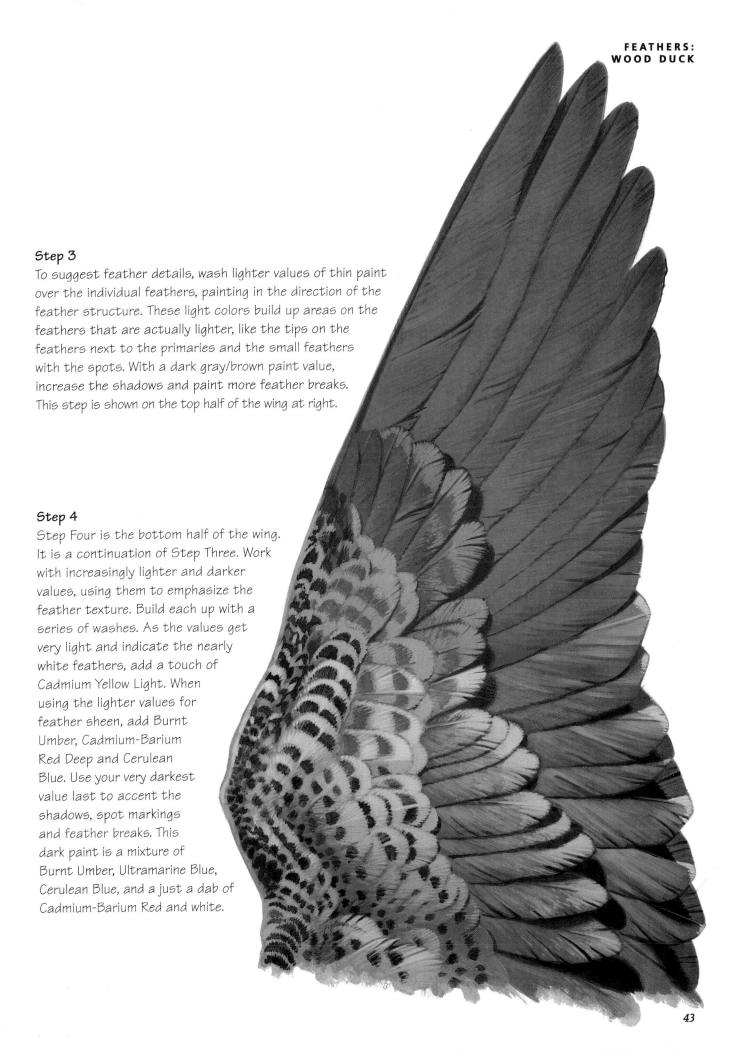

Step 3

To suggest feather details, wash lighter values of thin paint over the individual feathers, painting in the direction of the feather structure. These light colors build up areas on the feathers that are actually lighter, like the tips on the feathers next to the primaries and the small feathers with the spots. With a dark gray/brown paint value, increase the shadows and paint more feather breaks. This step is shown on the top half of the wing at right.

Step 4

Step Four is the bottom half of the wing. It is a continuation of Step Three. Work with increasingly lighter and darker values, using them to emphasize the feather texture. Build each up with a series of washes. As the values get very light and indicate the nearly white feathers, add a touch of Cadmium Yellow Light. When using the lighter values for feather sheen, add Burnt Umber, Cadmium-Barium Red Deep and Cerulean Blue. Use your very darkest value last to accent the shadows, spot markings and feather breaks. This dark paint is a mixture of Burnt Umber, Ultramarine Blue, Cerulean Blue, and a just a dab of Cadmium-Barium Red and white.

Folded Wing

PEREGRINE FALCON
(Acrylic)

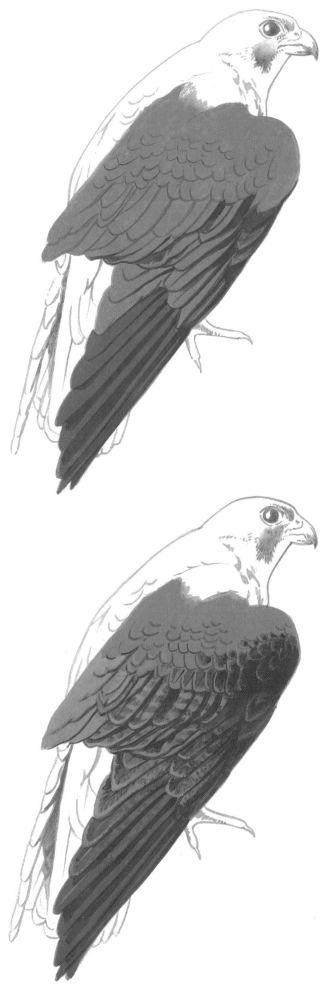

Step 1

The entire bird is shown here but, for now, concentrate only on the right wing. Peregrines have a blue-gray wing color so use that as your base paint. Transfer the major feather groups from your drawing to the painting. The lower primaries appear darker in the model, so use a darker, grayer value as a base there, and use the same color to outline the feathers above these primaries. This establishes their position so you can see them more easily to work on later. Mix a darker shadow color and begin to paint the shadows on each feather. This work is shown in progress on the lower half of the wing.

Step 2

Continue to paint the shadows and use the same value to suggest the feather markings. These can be applied as washes as they near the upper left portion of the wing, as this is the closest to the light source. Next, mix a lighter value of the base color with white, Cerulean Blue, and a tiny dab of Cadmium-Barium Red Deep and use it to show light reflecting off the feathers. You can also use it to start showing the lighter edges of the primaries, secondaries and coverts. I've left the top portion of the wing unchanged to show the progression.

Step 3

Start this step by mixing the next darkest value change. Add Ultramarine Blue, Cerulean Blue and more Burnt Umber to offset the color, so it won't be too blue looking. Use this and one more mixture of yet another darker value to work on the feather shadows and markings. Use washes and straight paint, working darker as you move to the feathers on the right, the shadow side. Mix two lighter values and paint in a similar method on the light side. Use these values in light washes, building up the glaze over several applications.

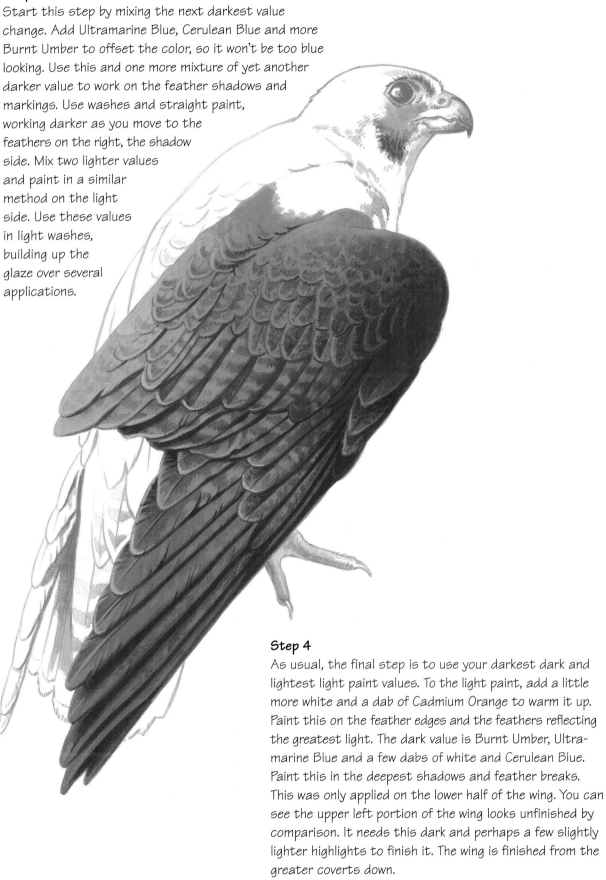

Step 4

As usual, the final step is to use your darkest dark and lightest light paint values. To the light paint, add a little more white and a dab of Cadmium Orange to warm it up. Paint this on the feather edges and the feathers reflecting the greatest light. The dark value is Burnt Umber, Ultramarine Blue and a few dabs of white and Cerulean Blue. Paint this in the deepest shadows and feather breaks. This was only applied on the lower half of the wing. You can see the upper left portion of the wing looks unfinished by comparison. It needs this dark and perhaps a few slightly lighter highlights to finish it. The wing is finished from the greater coverts down.

The Speculum

NORTHERN SHOVELER
(Watercolor)

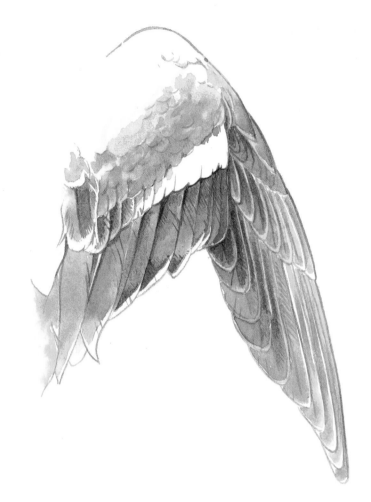

The area of green feathers shown in the watercolor illustration at right is called the speculum. This is the top view of the right wing of a duck commonly called the shoveler. The speculum is an area on many ducks where the feather color is bright and often iridescent. These ten feathers are also called the secondaries. The speculum is one of the major characteristics that can be used to identify waterfowl species. The change in color and brightness can be both fun and difficult to paint.

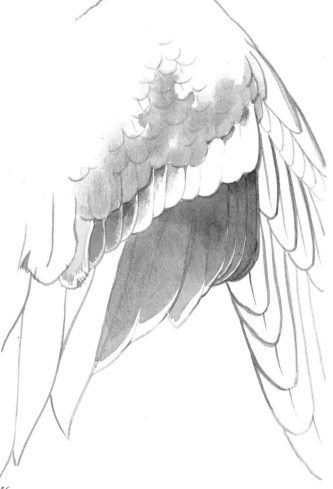

Step 1
Begin with a layout of the feather groupings. On a full wing, make sure you are depicting the correct number of feathers for the major feather groups. Here, with a partially closed wing, some of the ten secondaries of the speculum are hidden. Wet the speculum area first and then apply five different values of color. These range from the bluish green on the left to the brown on the right. Wash in some of the blue shoulder feathers to show how the whites of the greater covert feathers contrast with the speculum.

Step 2

Use some of the same colors to indicate more color changes and also some lines flowing in the direction of the feather structure. Use darker values, mostly Burnt Umber, to shadow some of the feathers and paint the darker markings on the feathers. I sometimes carefully overstate the shadows and contrast when painting feathers, to help me create the feather-like look.

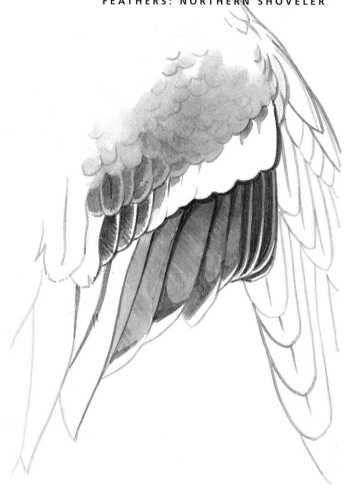

Step 3

Continue adding some subtle color washes to improve the shading on the feathers. Soften the edges on the darker color markings and softly color the leading edges that had been left white earlier. Moisten a few small areas of the speculum and blot them to make some lighter color spots. With the darkest value, deepen a few shadows and carefully add some lines to suggest feather breaks. These breaks certainly add to the look of feather texture; however, don't overdo these breaks or you will create a distraction.

Body Feathers

BLACK DUCK
(Acrylic)

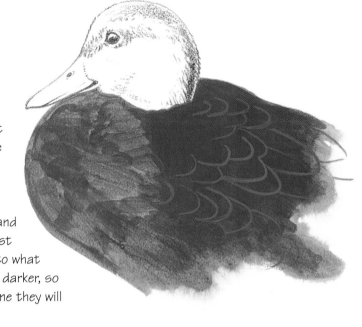

Step 1

Your first step is a series of washes to build up an opaque layer of paint. You want a color that is dark yet still a middle value of the duck's body. You can see the first wash on the chest and then two more used to get the opaque look. Use your transfer sheet to establish the feathers and then use color just light enough to contrast against the body color. The color is close to what you want to use as the feather edges but darker, so when you draw the feathers in the first time they will not be too stark.

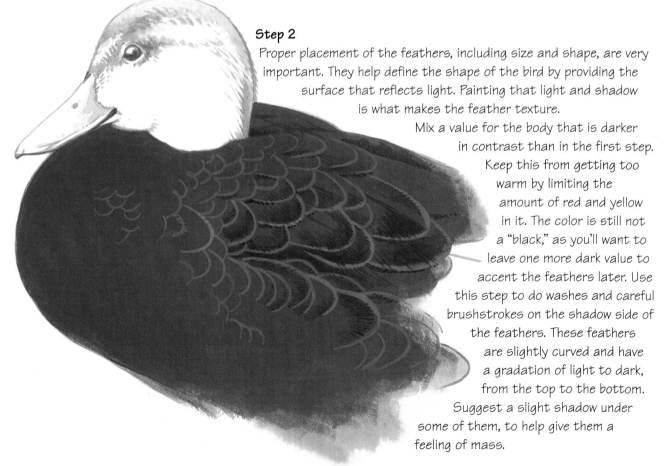

Step 2

Proper placement of the feathers, including size and shape, are very important. They help define the shape of the bird by providing the surface that reflects light. Painting that light and shadow is what makes the feather texture.

Mix a value for the body that is darker in contrast than in the first step. Keep this from getting too warm by limiting the amount of red and yellow in it. The color is still not a "black," as you'll want to leave one more dark value to accent the feathers later. Use this step to do washes and careful brushstrokes on the shadow side of the feathers. These feathers are slightly curved and have a gradation of light to dark, from the top to the bottom. Suggest a slight shadow under some of them, to help give them a feeling of mass.

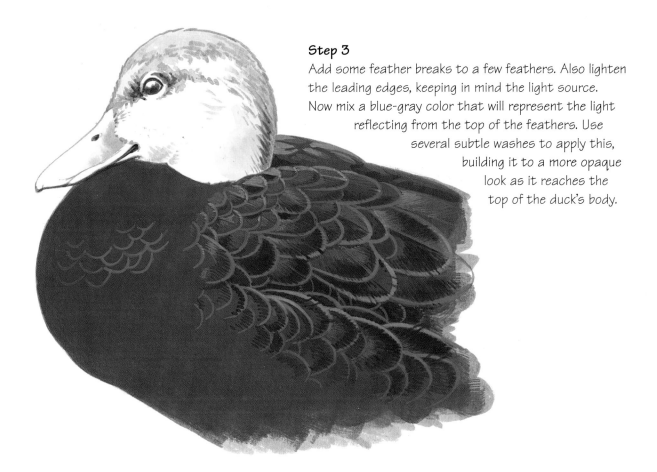

Step 3

Add some feather breaks to a few feathers. Also lighten the leading edges, keeping in mind the light source. Now mix a blue-gray color that will represent the light reflecting from the top of the feathers. Use several subtle washes to apply this, building it to a more opaque look as it reaches the top of the duck's body.

Step 4

If you compare these Steps Three and Four, you can see the changes in contrast. Use your final dark value to accent the shadows on the feathers and the splits in the feather edges. These edges are painted lighter again, applying the lighter color to the upper edges where the light would catch them. Use several lighter washes of the blue-gray color to paint the feather sheen high on the back and shoulder area of the body. The results should look like overlapping feathers that curve with the body.

Feathers–Song Bird

WHITE-THROATED SPARROW
(Acrylic)

Step 1

Because of the basic gray-and-brown pattern to this bird, break his form into these two color areas. Start with three base colors that can build on. One is a tan area for the back and wing feathers. The other two areas are gray, one for the head and then a warmer gray area for the rest of the body. It takes several thin coats of paint to build these areas to an opaque base. When this is done, use your transfer sheet to reestablish the feather patterns that had worked out on your layout drawing. Pencil some head details to show that area better.

Step 2

Mix a darker color paint for each area, but not so dark that it appears shocking. The greatest contrast is at the top of the head, because that area will be black against white. Use this step to "draw" with your paint, using thin washes and building up some areas for a more opaque look. The light is coming from above the bird, so make your shadows on the wing feathers thicker as they curve around and down the body. You can easily make corrections over this, as the contrast is not too bold. Later, you can deepen the areas necessary for darker shadows and add lighter values to accent the suggested forms.

Step 3

Use some slightly darker values in this step, but these are still far from what will be your final dark. Emphasize the form with darker shadows and indicate darker markings on the feathers. Also use some lighter values to begin the indication of light striking the birds' form. At this point you have a somewhat detailed but faded-looking bird.

Step 4

Some dramatic changes take place in this step as a result of the addition of the final dark and light paint values, and the brighter colors. Use washes of primarily Burnt Sienna to build up color on the wing, in the shoulder area. The yellow spots take several washes. Try to convince your eye that the wing curves from the top to the side by using color and value. Both are lighter on top and darker on the bottom. Use a thin wash of almost white to make a subtle sheen on the very top of the wing, where the light would reflect off these feathers. A few dark lines suggest feather breaks to complete the look of this beautiful songbird.

Head Study

RING-NECKED PHEASANT

(Acrylic)

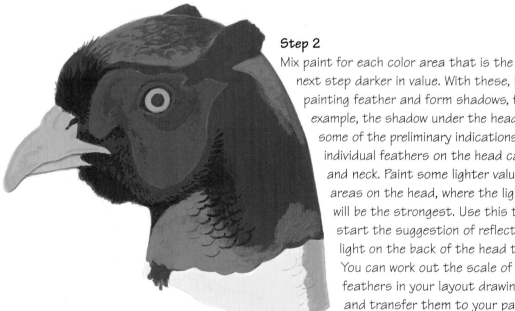

Step 1

Divide the head into five major color areas. For each one, mix a paint color that will be your middle value base. You can see the first coat on the back of the head; it will take several coats of paint to cover these areas. When viewed in the light, the head of the adult male pheasant seems to be a predominantly purplish color. This is why I started with the color shown for the head. (For this entire demonstration, I am using a worn no. 2 and a new no. 1 round sable brushes.)

Step 2

Mix paint for each color area that is the next step darker in value. With these, begin painting feather and form shadows, for example, the shadow under the head and some of the preliminary indications of individual feathers on the head cap and neck. Paint some lighter value areas on the head, where the light will be the strongest. Use this to start the suggestion of reflected light on the back of the head too. You can work out the scale of the feathers in your layout drawing and transfer them to your painting. You can see the transfer of these feathers in graphite on the white ring on the neck.

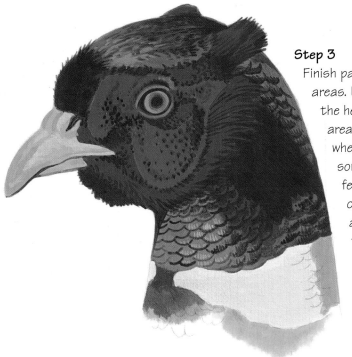

Step 3

Finish painting the feather details in all the color areas. Use the same procedures on the rest of the head, such as the bill and the red fleshy area. Use the next lighter value to begin showing where the light is striking the feathers. Put some nearly white highlights on some neck feathers that are in bright light. I put a color wash over these, which sometimes achieves a better color effect than trying to mix a solid paint of that particular color. You should use some subtle washes on most of these detailed feather areas to suggest the changing color and iridescence.

Step 4

Your final lights and darks are added now. Paint the dark value first, using a mixture of Ultramarine Blue, Burnt Umber, and Payne's Gray. Use this to deepen the shadows and accent the feather texture. Employ the light value to accent the light on the feathers and emphasize the texture. Notice the difference in feather size even on this head. There are some very tiny feathers near the bill. There are some long flowing, brownish feathers near the back of the red area of the head, as well as the feathers that form the characteristic "horns" or "ears" on the top of the head.

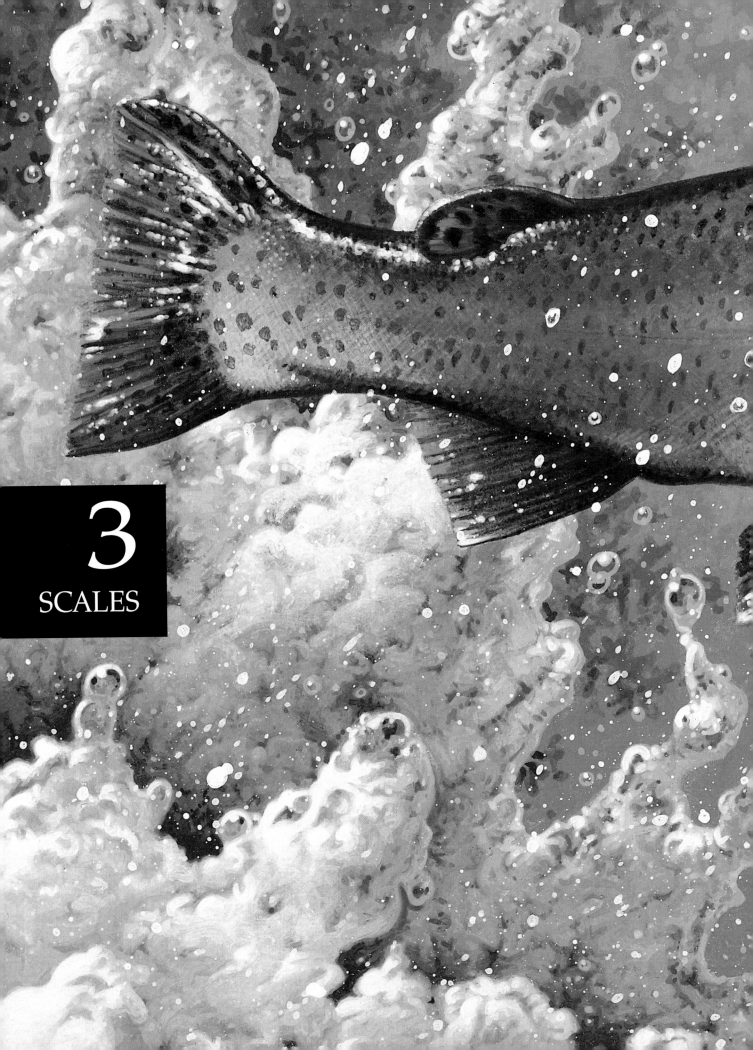

3
SCALES

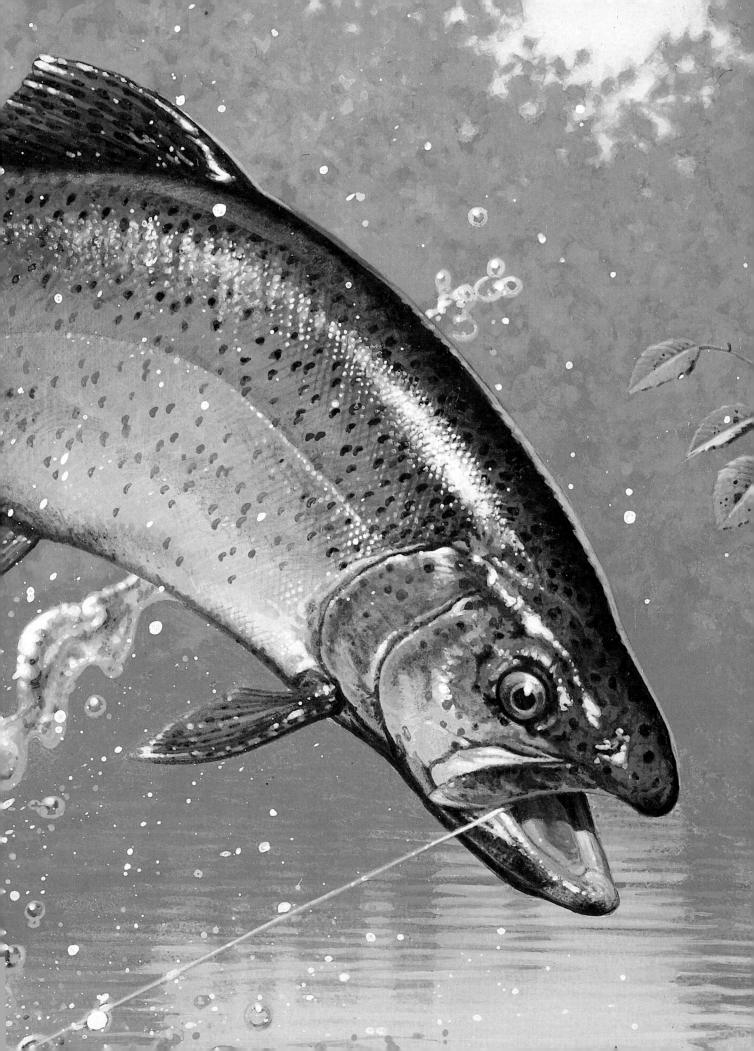

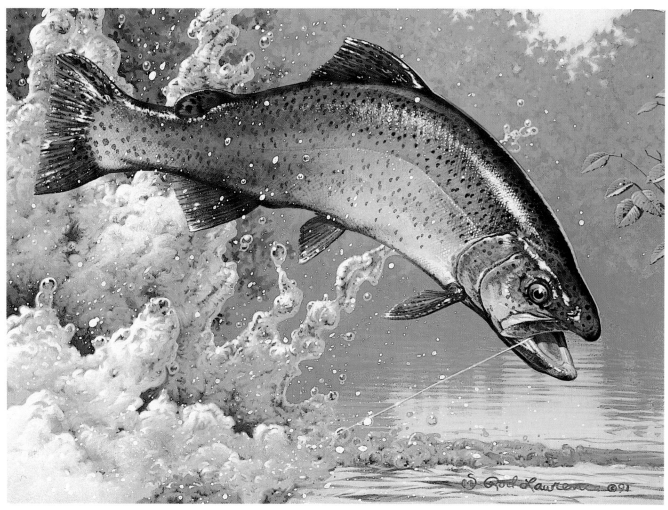

RAINBOW TROUT *Acrylic, 7" x 9 ¹/₄", The Lang Collection*

SCALES make most of us think of snakes and fish. But there is a much larger variety of wildlife with scales or scale-like coverings, such as armadillos, turtles, alligators, and lizards just to name a few. Like fur and feathers, scales provide the important outside covering for the animal. They come in a wide variety of sizes, shapes and thicknesses. Compare the large, thick scales of a fish like the carp with those of the trout, whose scales are very tiny and thin. Scales have a distinct visual and tactile texture that is important to capture when creating a realistic painting of a scaled creature.

To paint scales, you must be aware of how they change size and shape depending on what part of the creature's body they cover. In addition, look for the geometric pattern that seems to change with the movement of the animal and its body contours. This pattern appears to look concave or convex according to the body structure. Scales can be painted very subtly with the paint giving just slight suggestions. Use shadows and highlights to make more defined scales stand out. I always plan the pattern of the scales before the actual painting because it is very important to draw the scales in the right size, shape and pattern. It is so much easier to paint them, whether subtle or pronounced, if you have them worked out in advance. Doing the planning is often more difficult and time-consuming than the actual painting, but well worth the effort.

Start With a Grid
First, establish a grid pattern for the scales and afterwards use paint to form them.

This curved area worked out quite successfully and as a result seems to visually flow nicely.

However, this area in the middle of the back appears a bit confusing. This becomes visually disturbing and shows why it is so important to keep the pattern of scales flowing correctly for the species you are painting.

Scales can vary greatly among the same species. Most snakes have long scales under the body, but the sides can be quite different. These are similar to a rattlesnake's scales, somewhat pointed and overlapping.

The use of light and dark values can determine how smooth or rough the scale texture looks.

On parts of a cobra, the scales appear to be oval "bumps" like these.

Scale Texture

LAKE TROUT
(Watercolor)

Step 1

The scales of a trout are quite fine. We will take a close-up section of a trout to paint this sample of scale texture with watercolor using no opaque paints. First, do a simple drawing of the area and carefully plan the scale area. Then make transfer sheets of both the markings and the scale pattern. Then you can transfer the side patterns of the fish onto the body before applying paint. This will guide you in the application of water to control the flow of the paint around the markings.

Step 2

Apply paint to the fish in five basic areas. These are the two gill coverings, the bottom section, the top section above the lateral line, and the middle left area of the body. By dividing the fish up into these areas, you can work on each separately. Start by applying water to the body and then use color washes to flood the area. Keep the washes light in color and value, painting from dark to light according to the light source and shape of the fish. Now you have a base to build on.

Step 3

Some darker washes define the gill and pectoral fin area. Then use your transfer sheet that has the planned scale pattern and trace the lines onto the painting. This establishes the scale grid that you will use to paint the scales. Vary the way you define the scales. In some areas, paint around the entire scale, such as on the back near the lateral line and on the body near the gill opening. In other areas, use dark dots like a shadow on the scale, as seen in those high on the back of the fish. On areas that have more shine, use just a little dot of light wash or shadow two sides of the scale, as in the lower left.

Step 4

For this step, continue painting all the areas as mentioned above. On the back, use some broad strokes of darker value to continue the suggestion of scale rows. Near the lateral line, use a clean brush and water to soften the paint on a few scales and lift the pigment up. If necessary, blot it with a tissue. This will give you a lighter value scale for a good effect. You can also add some darker details and color to the other areas of the painting while working on the scales. The last application of paint is a thin light wash to color some of the markings on the body and gill covers. This will allow the scale detail to show through and provide some contrast and shadow to these areas of the painting. It helps add to the illusion of form and suggest light and shadow.

Painting Scales

SUNFISH
(Acrylic)

Step 1

Apply a base coat of a medium light color. It should be about two steps darker than what will be your final light color. After several coats to build up the base, use a medium dark value to start painting some shadows and suggest the form of the fish. Then use your transfer sheet to draw the grid marks representing scales onto the painting. Plan these carefully, taking into consideration the relative size of the scales in comparison to the fish, and also how they follow the contour of the body. Then with the medium value paint, start defining individual scales.

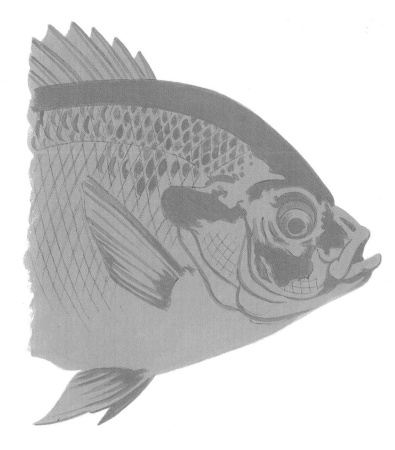

Step 2

After painting the scales with the medium dark value, use a wash of acrylic to apply some color on the back of the fish and around the gill area. The wash allows the detail of the previously painted scales to show through and softens the contrast between the scales and the base coat.

On the belly of the fish, use a different approach. First, apply an opaque area of color, primarily Yellow Ochre Light. Then use the base coat color to paint a grid that matches the size of the scales for the area. Work back and forth with the two colors to refine the look of these scales.

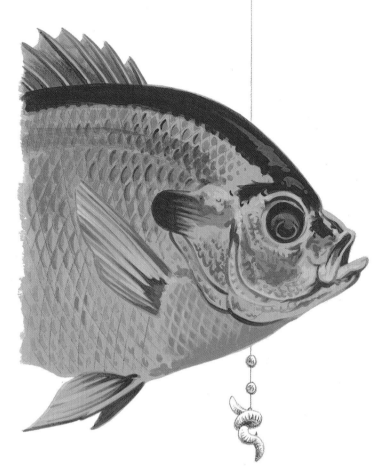

Step 3

Now begin some more dramatic value changes. Use a dark value to accent the deep areas of the eye, mouth and back of the fish. Note that the dark on the back of the fish has an irregular edge, keeping with the feeling of scales in that area. You can also use this color to accent some of the scales and shadows. With a lighter value mixture, begin the suggestion of light and reflections striking the fish body. This helps develop the form and structure, giving the fish a more solid look. Use this light color to highlight scales and create contrast between some others. A darker wash is applied over the back of the fish, under the highlight.

Step 4

Here, add a really dark color made of Ultramarine Blue and Burnt Umber. Use this to set the eye with a deeper-looking socket. You can also use it on the mouth, gill and above the eye. Take a blue-gray mixture and wash it from behind the eye and down the back. Build this up with several washes, allowing the scales to show through, keeping it more opaque near the eye. Use your lightest value of Cadmium Yellow Light and white to build the bright highlights. This is also washed on the area behind the eye to intensify that highlight. Use bright washes to work softly around some of the scales as well. It would be easy to add more color washes over the painting if you want to make the fish brighter. The washes would be transparent to allow the scales to show through. Just a little reworking of the dark and light accents would be necessary because the washes will dull both the light and dark values.

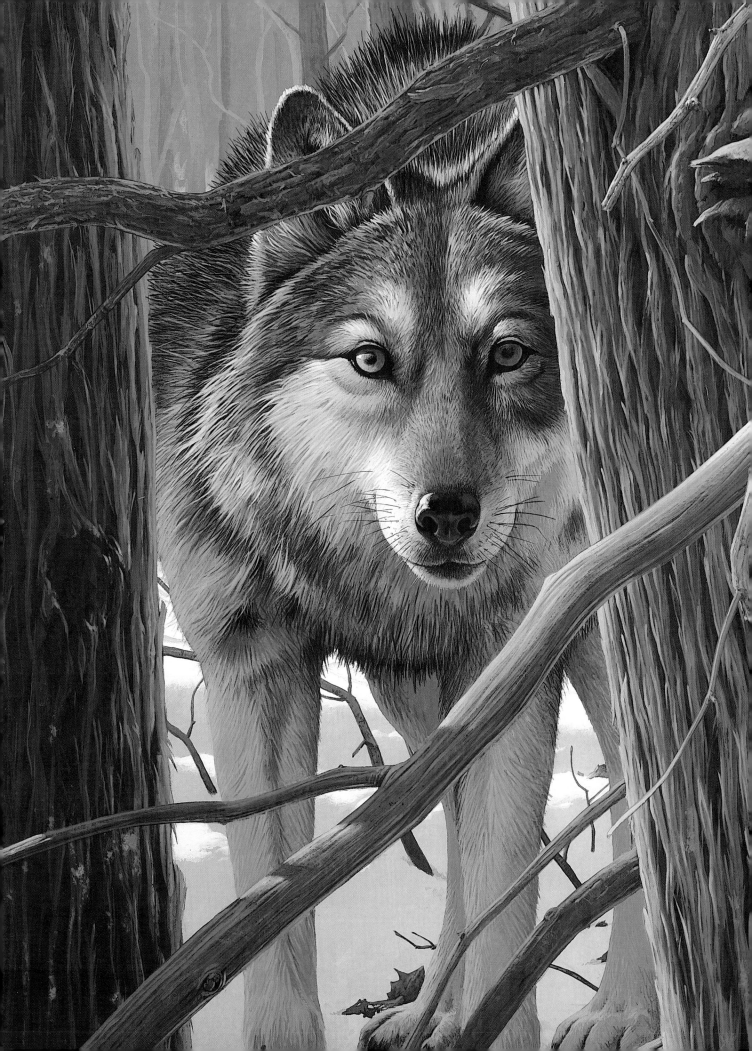

4

EYES & EARS

Rod Lawrence

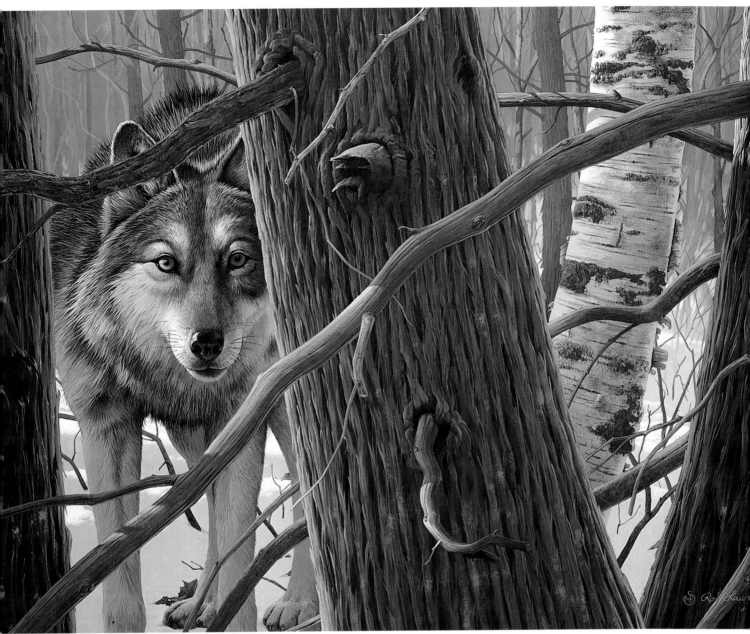

FACE TO FACE
(Gray Wolf) Acrylic, 16" x 24", Collection of Heatherlee and Gregory Gosnick

EYES are not just another element of wildlife painting. They are crucial in making your wildlife subject come alive. If the eyes in a painting look dull and dead, then the animal itself appears to be lifeless. A good eye should look moist, rounded, and it will reflect the world around it. This is what can truly give a wildlife subject the spark of "life."

Good reference is important, especially in those instances that you will be painting a detailed eye that will show the iris color and pupil shape. While the eyes of many creatures are quite similar, some are uniquely different. Some even vary in color according to sex within the same species.

The eyes of certain species have a very distinct look, having a lot to do with the location of their eyes on the head. The pronghorn and woodcock are good examples of this.

The texture of most eyes is very similar, the real textural differences being in the area immediately surrounding the eye, the eye socket.

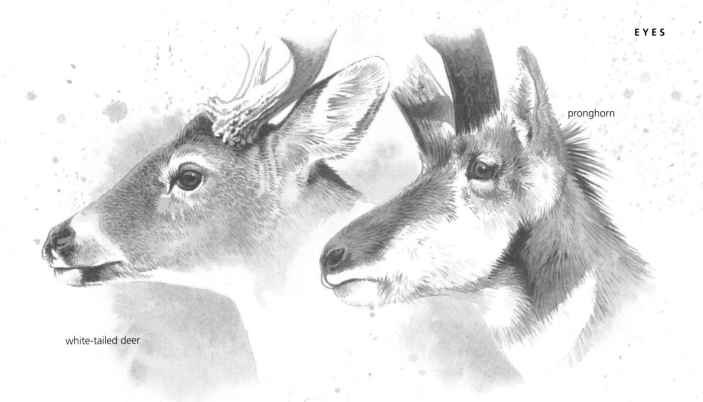

pronghorn

white-tailed deer

Research Eye Placement Carefully

The eyes are perhaps the most important way that we make direct contact with wildlife subjects in a painting. Consequently, the relative size, shape and placement of the eyes are critical in having a wildlife species look "right." Some species have an unusual eye placement that appears to look abnormal to us when compared to other similar subjects. Be sure to research carefully and place the eyes where they really are, not where you think they should be. Consider the eyes of the pronghorn and the woodcock. Compare their placement to that of those in the related species shown here. Did you ever notice that most predators seem to have placed to the front for hunting and most prey have eyes more to the side for defense?

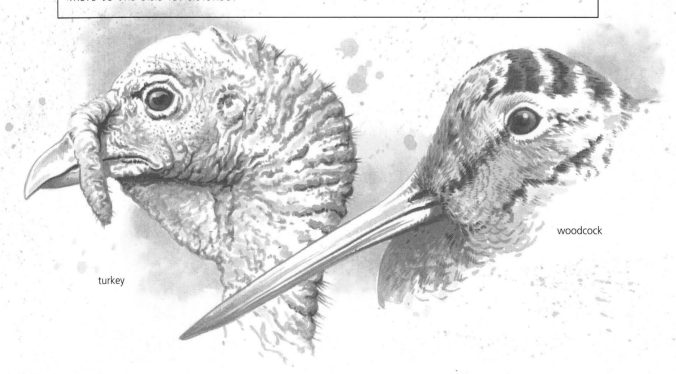

woodcock

turkey

Painting Eyes

RED-TAILED HAWK
(Acrylic)

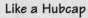

Like a Hubcap
I have always thought of the eye as having the same basic characteristics as a chrome automobile hubcap. The hubcap reflects the world around it, much like a concave mirror.

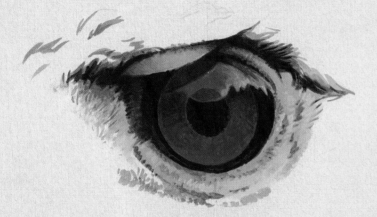

Overcast Day
On an overcast day, the eye reflects the cloudy sky, but there is not a definite white spot (the sun) of a highlight. The iris color is not as intense, as there is no bright sun shining on it.

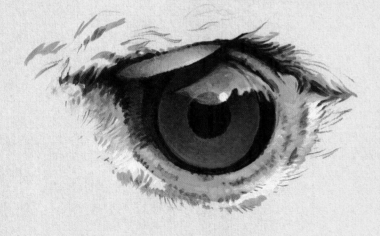

Bright Day
On a bright, sunny day the brightest spot in the sky, the sun, will be reflected as the familiar white dot. The direction of the light in relationship to the eye will determine the reflection seen.

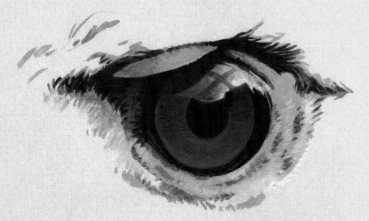

Careful Using Photos
Keep the above in mind when using reference photos. When more than one bright highlight is visible, it is usually the result of windows from indoor photos, or the photographer's flash equipment. These are not natural-looking highlights you would see in the wild.

WOLF EYE
(Acrylic)

The following illustrations are shown in two quick stages. They illustrate the basic differences in rendering eyes, depending on the animal's placement within the picture plane. As you review this, you will realize that light source, habitat, and size are very important in painting the eyes.

In the Distance
Wildlife viewed from a distance has much less detail, therefore the eyes are done very simply with little or no color, simple shapes and highlights.

Intermediate Range
For those eyes in an intermediate range, more color and detail become apparent. This gives the eye more dimensional form and shape. The reflection is more complex.

Close Up
This eye is up close and very detailed. This is actually a continuation and refinement of the intermediate-range eye shown above. The reflection is more refined; there are more color changes in the iris, and more defined light and shadows.

Eyes Step by Step

COYOTE
(Watercolor)

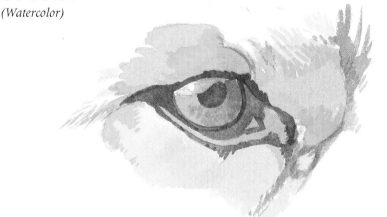

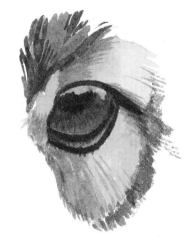

Step 1
Wash in the basic shapes with a light wash, be especially careful to protect the area of reflection. You can wet small areas of my paper to control the color flow.

Step 2
Although this eye is in shadow, the same approach applies. Slightly wet areas like the iris to flow in some subtle color changes. Blotting with a finger or cloth can give a nice effect.

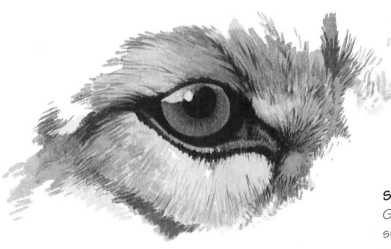

Step 3
Gradually, keep adding subtle darker glazes to add color variation and to defining the shades.

Step 4
Save the final step for this eye that is more in the sun. It is the more important because it will have the most visual impact. Continue as in Step Three adding darker values and details in short, careful strokes. After all the darks are complete, put a slightly bluish wash in the reflection, leaving the white spot clear and clean.

ELK EYE
(Acrylic)

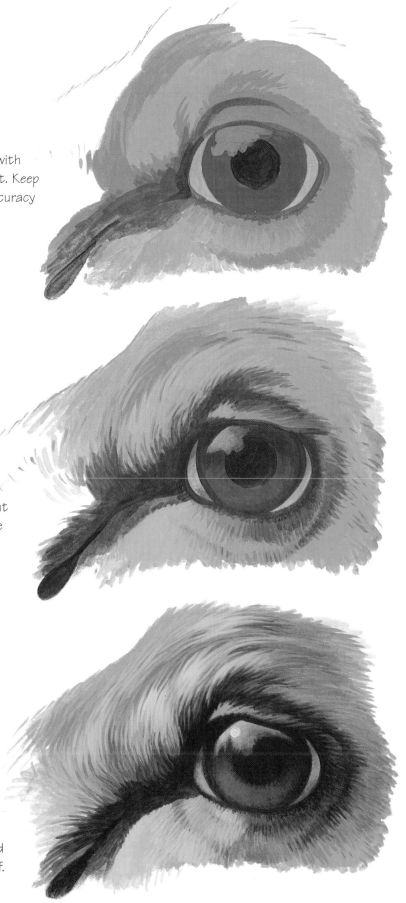

Step 1
Establish the major areas of the eye with middle values, nothing too dark or light. Keep the details down and maintain the accuracy of your layout drawing. (I used a no. 2 round for this demonstration.)

Step 2
Use the next value darker to make the appropriate areas of the eye and socket appear to "sink in" and have depth. The next lighter value is used for just the opposite, to bring out the raised and more lighted areas. The first thin wash for the sky reflection is a mix of Titanium White, Cerulean Blue and a slight touch of Cadmium-Barium Red Deep.

Step 3
Refine and continue the subtle changes from light to dark in the iris and reflection. The sun has made its appearance and the effect of light and shadow is clearly seen on the eye itself.

Bird & Fish Eyes

GREAT HORNED OWL
(Acrylic)

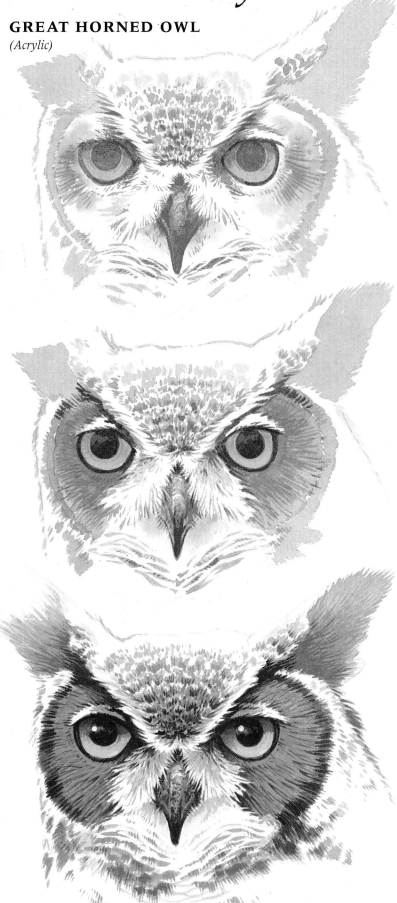

Step 1
With a light wash of Burnt Umber and Cerulean Blue, render the basic form and a few details, including the large pupil. Next, wash in the iris with Cadmium-Barium Yellow Medium mixed with a slight amount of Burnt Umber and white. The dark pupil will show through so you can redefine it later.

Step 2
Add some touches of Yellow Ochre Light and then Burnt Umber to indicate shadows and variations on the iris. A mixture of white, Cadmium-Barium Red Deep, Ultramarine Blue and a touch of Burnt Umber is used as the base reflection at the top of the eye. Build this up slowly, glazing to make it more opaque.

Step 3
The lightest lights and darkest darks are now put in. These especially help put that spark of "life" into the eyes. When you look at this stage of the owl's eyes he should appear to be looking back at you!

RAINBOW TROUT
(Acrylic)

Step 1

Good fish eye reference is hard to come by. Fish dry and change color very rapidly when out of water. Underwater, they appear quite drab and dull, so I prefer to paint them as if they had just come out of the water, wet and glossy. I use the same approach here as on the owl, but keep in mind the wet glossy look you want for the eye and surrounding structure. Here, the base colors are washed in with some preliminary detail.

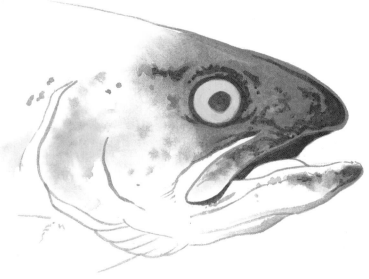

Step 2

Be mindful of the pupil shape and note how there often is a narrow light band of color around the pupil. The absence of an eyelid causes the pupil to appear more centrally located than the owl's. The mucus-like covering on fish will somewhat distort the shine and reflections, but the same general ideas for reflections apply here.

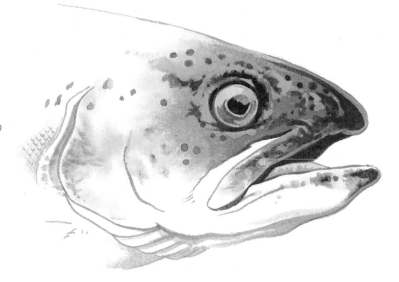

Step 3

Use light washes of color with a slightly bluish cast to build up areas of strong light. Finish these with a warm white. The strong darks now serve to bring out the contrasts in the eye and define the eye socket. Use light washes to slowly build up areas, instead of quickly going "overboard!"

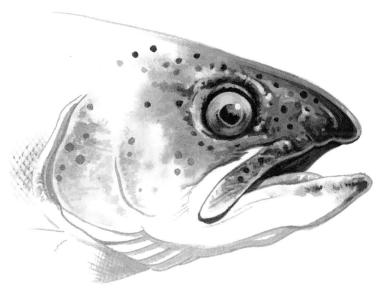

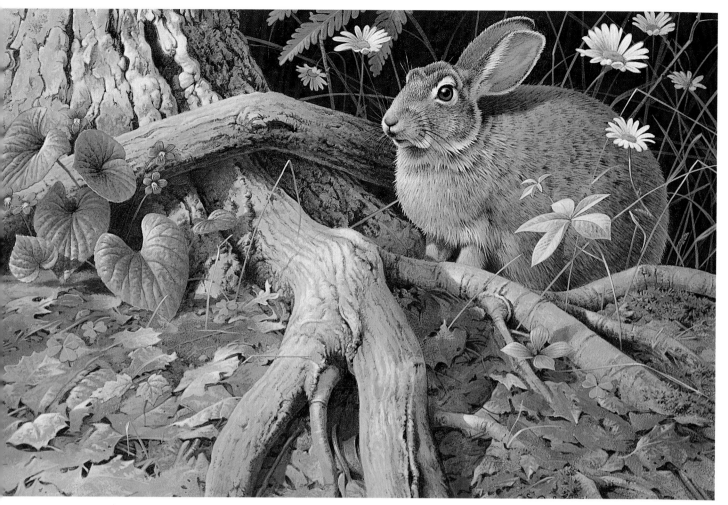

AMONG THE DAISIES
(Cottontail Rabbit) Acrylic, 10" x 15", Collection of Sue Lawrence

EARS provide wildlife with one of the most important of all the senses, hearing. Some species rely on it for survival, either as a predator to locate a meal or as prey to avoid predators. From a painting standpoint, the ears that are obvious to the viewer are most important to the painter. In many species that have larger external ears, placement and position is very important.

Different moods and effects can be achieved in a painting just by how the ear is portrayed, such as rotating them up, down, back, forward, or even independent of each other.

In addition to sounds, ears are full of a variety of textures and color changes. Their mix of short and long hairs, along with the deeper ear canal can be a challenge to the artist.

Painting Ears

COTTONTAIL RABBIT
(Watercolor)

Step 1
Your first washes of watercolor should be very light with the objective of keeping the light areas open for later color washes. Use this first step to loosely draw and indicate the forms and shadows so that I can build on them in the next step.

Step 2
Carefully plan the light hair areas as I did here, or use masking fluid to protect them. Now wash in some other subtle colors and darker value. Add more details, trying to sculpt the ears into shape with short strokes and subtle value changes within the ear.

Step 3
Now establish the darkest areas of the ears and touch up all areas for shadow and detail. At this point ask yourself if everything is working together well for good color and value balance. Do all the details visually make sense? Is there any area that makes you ask, "What is that supposed to be?!"

Painting Ears

WHITE-TAILED DEER
(Oil)

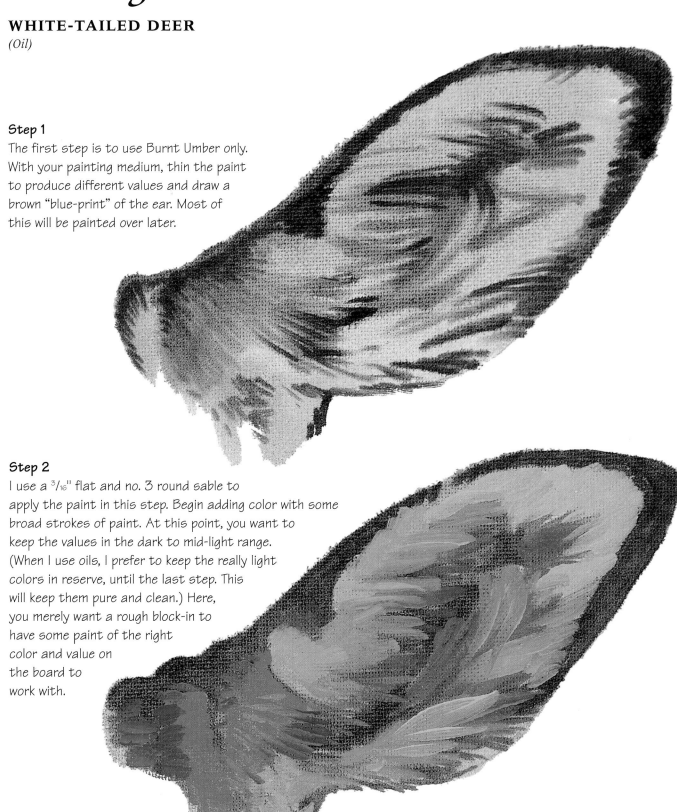

Step 1

The first step is to use Burnt Umber only. With your painting medium, thin the paint to produce different values and draw a brown "blue-print" of the ear. Most of this will be painted over later.

Step 2

I use a ³/₁₆" flat and no. 3 round sable to apply the paint in this step. Begin adding color with some broad strokes of paint. At this point, you want to keep the values in the dark to mid-light range. (When I use oils, I prefer to keep the really light colors in reserve, until the last step. This will keep them pure and clean.) Here, you merely want a rough block-in to have some paint of the right color and value on the board to work with.

Step 3

As you add more color and detail, make sure the color is just the value and intensity you are looking for. Use a round brush to drag the paint around the ear opening and suggest hair direction and details. Paint some hair details and add some darker values around the ear, indicating the darker hair that grows on these edges. Refine this step a little beyond what is shown here and then allow it to dry for a few days.

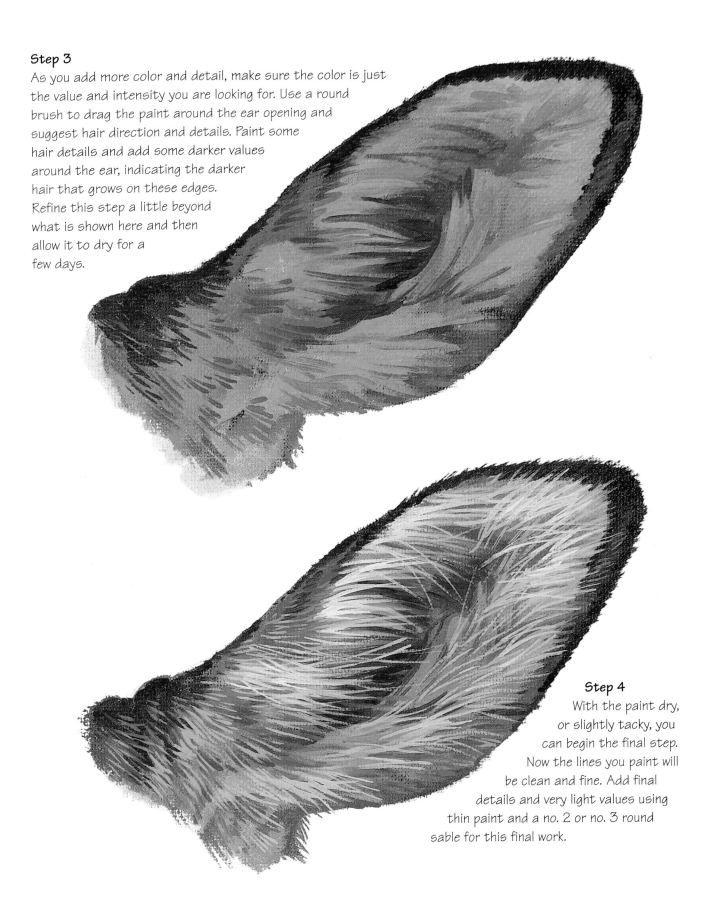

Step 4

With the paint dry, or slightly tacky, you can begin the final step. Now the lines you paint will be clean and fine. Add final details and very light values using thin paint and a no. 2 or no. 3 round sable for this final work.

Painting Ears

RED FOX
(Acrylic)

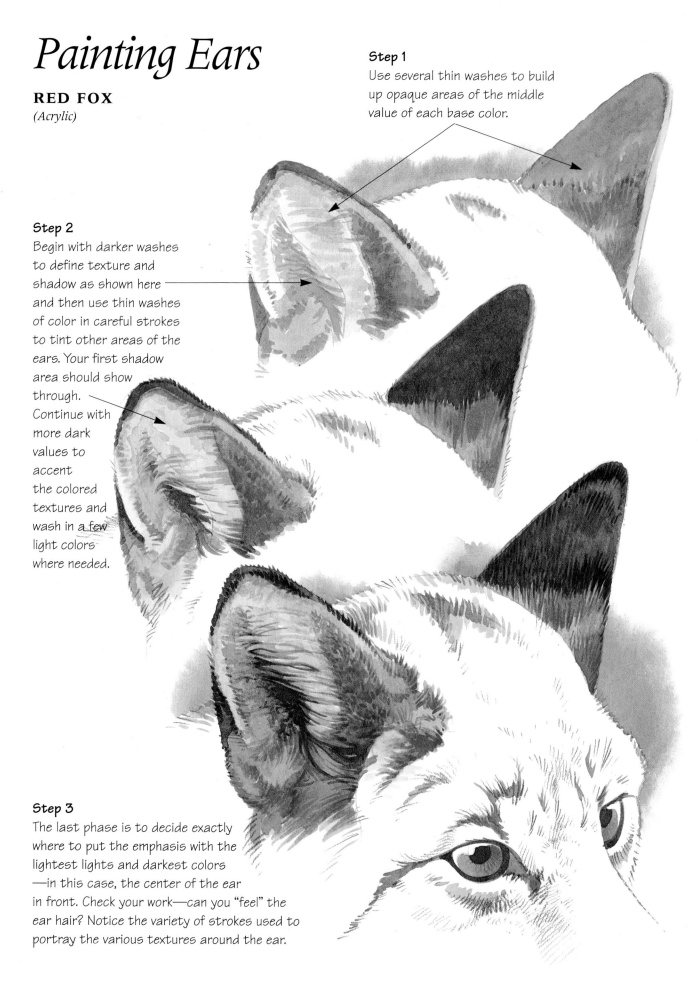

Step 1
Use several thin washes to build up opaque areas of the middle value of each base color.

Step 2
Begin with darker washes to define texture and shadow as shown here and then use thin washes of color in careful strokes to tint other areas of the ears. Your first shadow area should show through. Continue with more dark values to accent the colored textures and wash in a few light colors where needed.

Step 3
The last phase is to decide exactly where to put the emphasis with the lightest lights and darkest colors —in this case, the center of the ear in front. Check your work—can you "feel" the ear hair? Notice the variety of strokes used to portray the various textures around the ear.

BOBCAT
(Acrylic)

Step 1

This is a variation of the fox ears. Use several medium values of base colors. Work wet into wet quickly, keeping in mind hair direction as you use brushstrokes to blend. Do not overwork; allow the blending to work for you. Let this step dry before going to the next step.

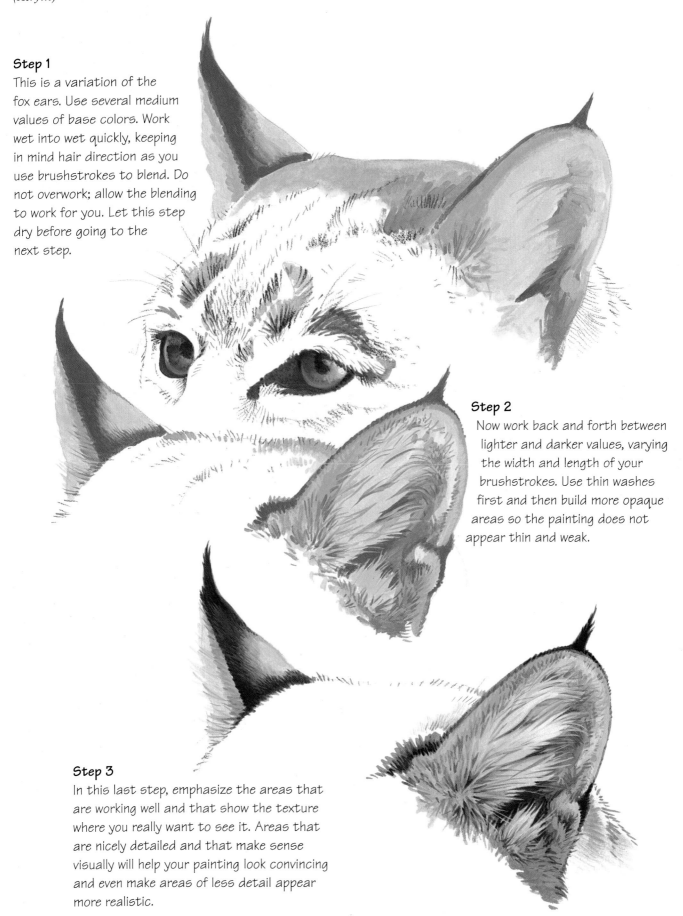

Step 2

Now work back and forth between lighter and darker values, varying the width and length of your brushstrokes. Use thin washes first and then build more opaque areas so the painting does not appear thin and weak.

Step 3

In this last step, emphasize the areas that are working well and that show the texture where you really want to see it. Areas that are nicely detailed and that make sense visually will help your painting look convincing and even make areas of less detail appear more realistic.

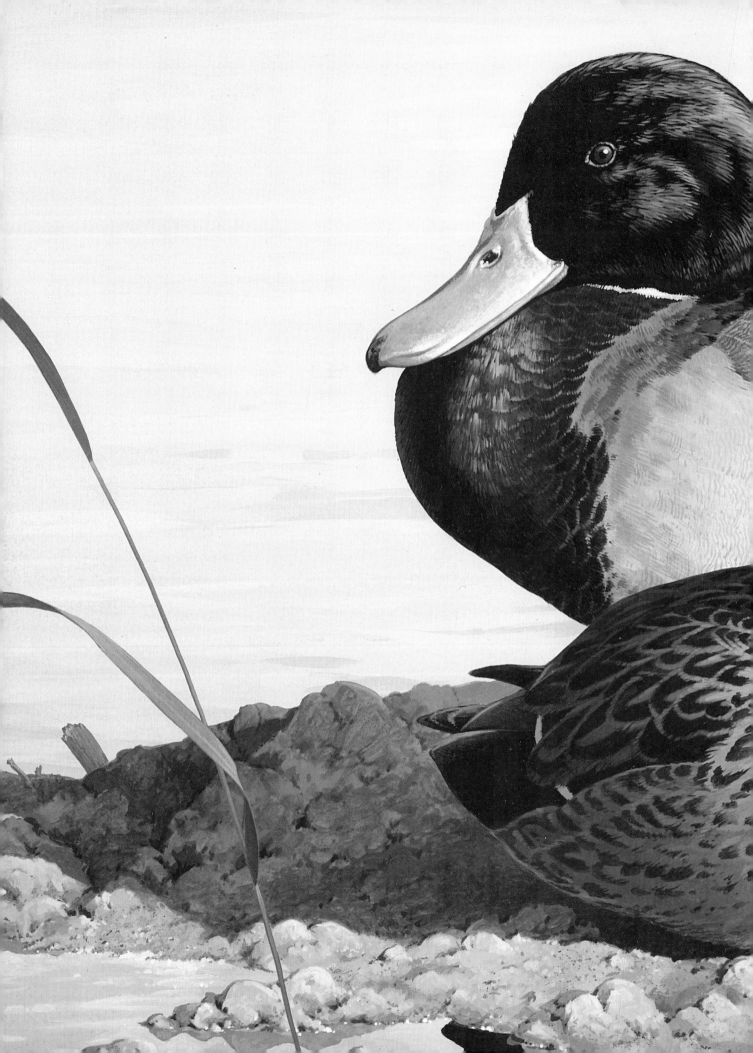

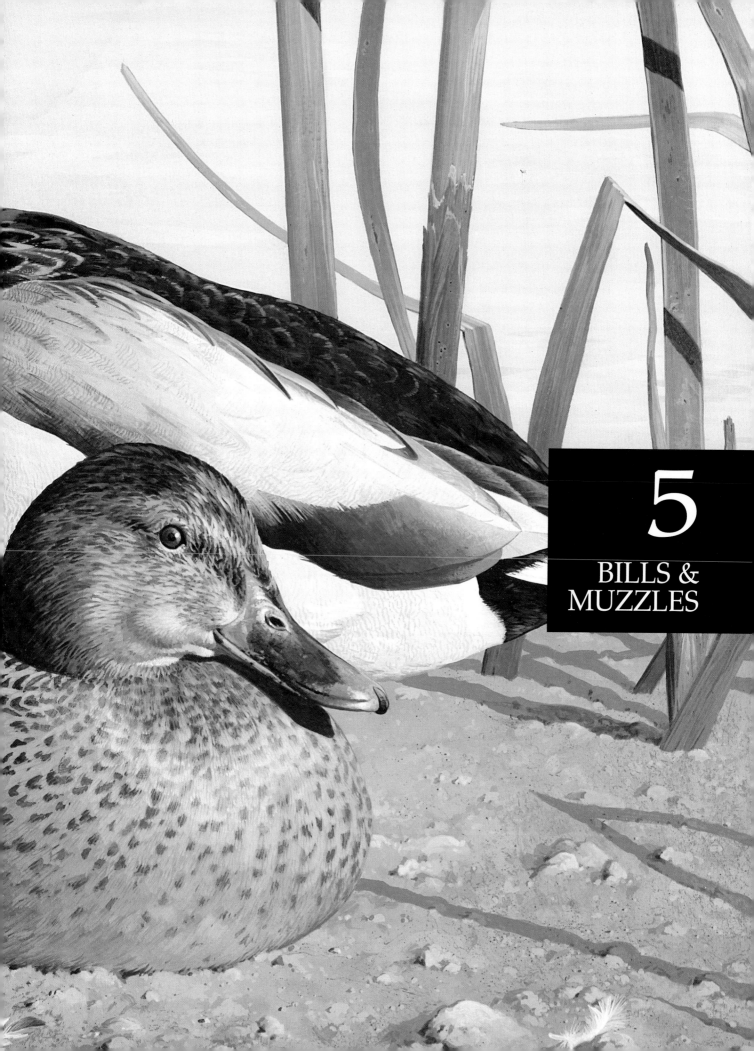

5

BILLS & MUZZLES

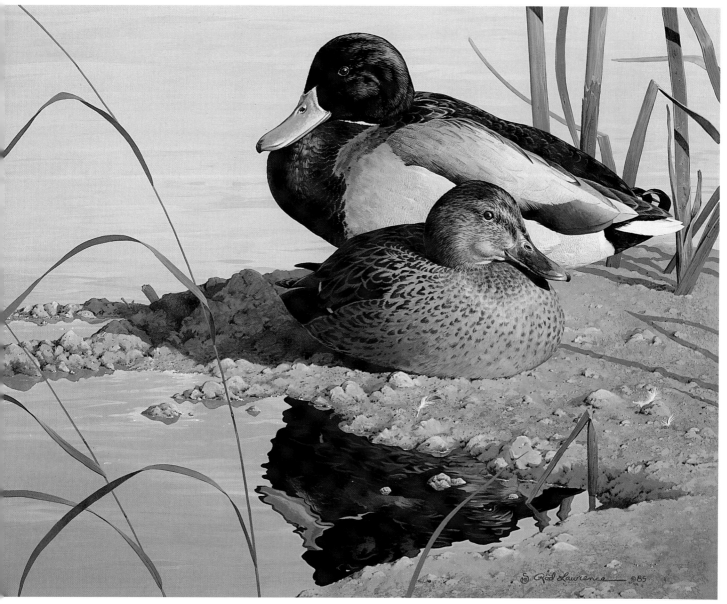

MORNING MALLARDS
(Mallard Ducks)
Acrylic, 16" x 20", Collection of Dr. and Mrs. William Northway

BILLS are primarily used for eating and the functions related to it. The wildlife world has a seemingly endless variety of bills. The vast differences in size and shape result in some very peculiar -looking creatures. These various shapes and sizes are nature's adaptations for the specialized need of that particular creature regarding its food source. For example, some birds have to have powerful jaws to crack seeds. Others have special beaks to strain water and mud to obtain insects or algae. Some variations are for other uses, such as display or even for killing.

Bills are an important part of painting wildlife. Each creature with one of these uniquely shaped beaks has a resulting distinctive look. Portraying the proper size and shape bill for a particular bird is really a large part of making that creature look anatomically correct in a painting. While the size and shape within some species may be identical for all individuals, there are species in which bill color varies between the sexes. Proper research can help answer many questions and avoid potential problems.

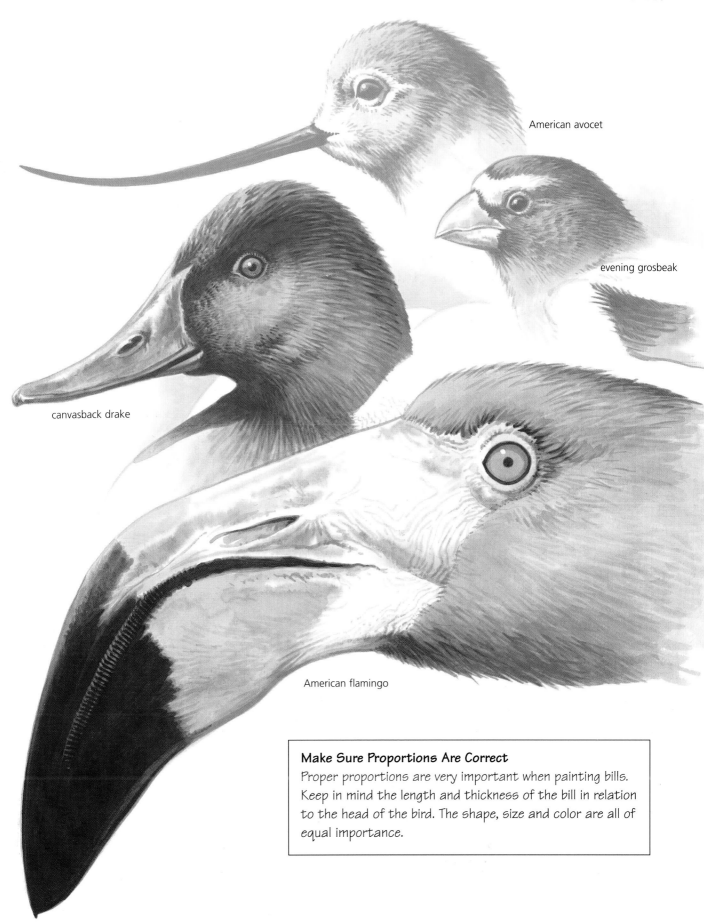

American avocet

evening grosbeak

canvasback drake

American flamingo

Make Sure Proportions Are Correct
Proper proportions are very important when painting bills. Keep in mind the length and thickness of the bill in relation to the head of the bird. The shape, size and color are all of equal importance.

Painting Bills

MUTE SWAN
(Watercolor)

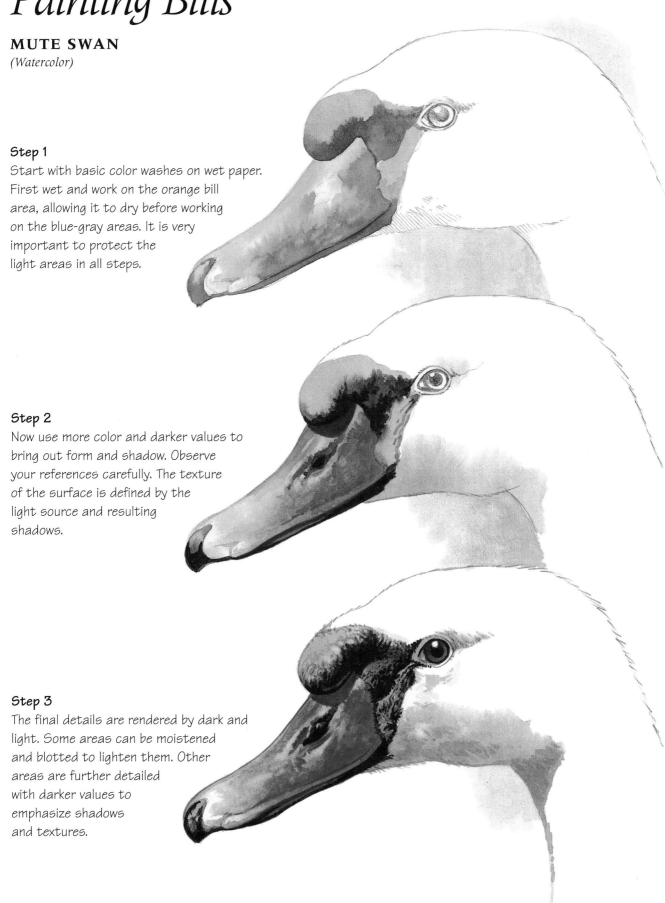

Step 1
Start with basic color washes on wet paper. First wet and work on the orange bill area, allowing it to dry before working on the blue-gray areas. It is very important to protect the light areas in all steps.

Step 2
Now use more color and darker values to bring out form and shadow. Observe your references carefully. The texture of the surface is defined by the light source and resulting shadows.

Step 3
The final details are rendered by dark and light. Some areas can be moistened and blotted to lighten them. Other areas are further detailed with darker values to emphasize shadows and textures.

NORTHERN CARDINAL
(Acrylic)

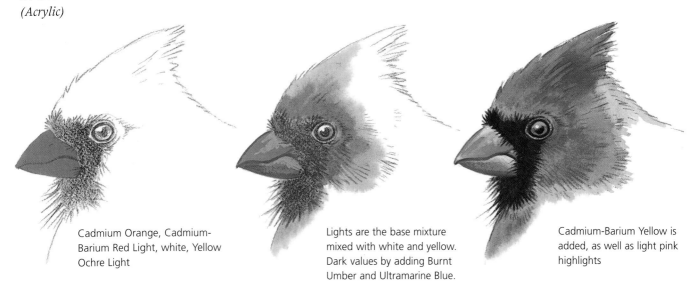

Cadmium Orange, Cadmium-Barium Red Light, white, Yellow Ochre Light

Lights are the base mixture mixed with white and yellow. Dark values by adding Burnt Umber and Ultramarine Blue.

Cadmium-Barium Yellow is added, as well as light pink highlights

Step 1
These two illustrations are very different in color hue, but the steps in painting them are identical. Begin with a solid opaque base color of a medium value to build on in the next steps.

Step 2
Use a darker value to establish the shadow lines and a lighter value to indicate those areas reflecting light. These are subtle changes to build up later with stronger contrast.

Step 3
Add the final areas of detail, the darkest and lightest values. These will be the strongest areas of contrast for the painting and put the painting in sharp focus.

MALLARD
(Acrylic)

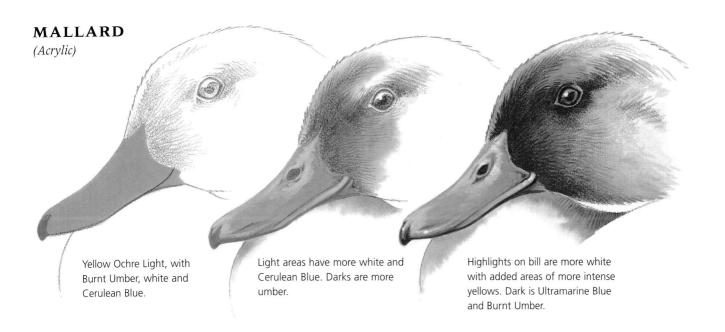

Yellow Ochre Light, with Burnt Umber, white and Cerulean Blue.

Light areas have more white and Cerulean Blue. Darks are more umber.

Highlights on bill are more white with added areas of more intense yellows. Dark is Ultramarine Blue and Burnt Umber.

GREAT BLUE HERON
(Acrylic)

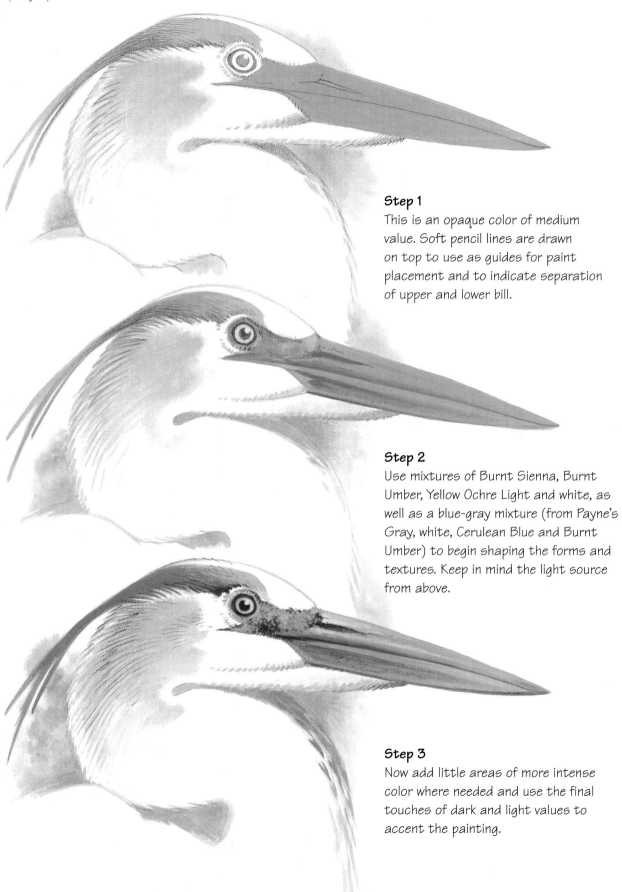

Step 1

This is an opaque color of medium value. Soft pencil lines are drawn on top to use as guides for paint placement and to indicate separation of upper and lower bill.

Step 2

Use mixtures of Burnt Sienna, Burnt Umber, Yellow Ochre Light and white, as well as a blue-gray mixture (from Payne's Gray, white, Cerulean Blue and Burnt Umber) to begin shaping the forms and textures. Keep in mind the light source from above.

Step 3

Now add little areas of more intense color where needed and use the final touches of dark and light values to accent the painting.

BALD EAGLE
(Watercolor)

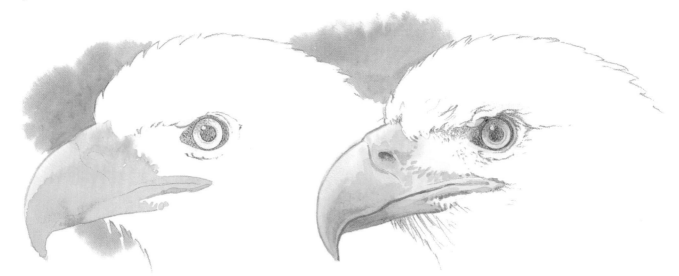

Step 1

Plan the light and dark areas of the painting. Wet the area first and apply color washes according to the light source and color pattern.

Step 2

Slowly build up the color, shadow and dark areas. The colors used here are Yellow Ochre Light, Cadmium-Barium Yellow Medium, Cadmium Orange and Burnt Umber.

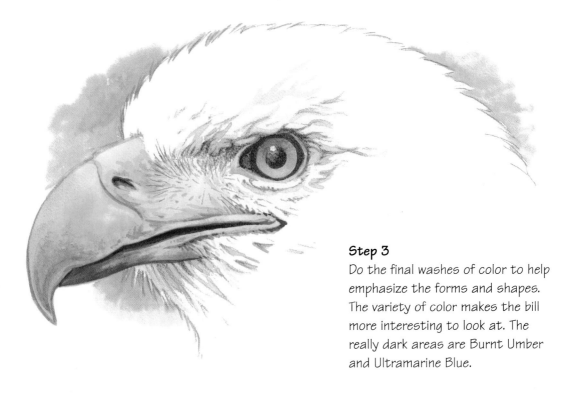

Step 3

Do the final washes of color to help emphasize the forms and shapes. The variety of color makes the bill more interesting to look at. The really dark areas are Burnt Umber and Ultramarine Blue.

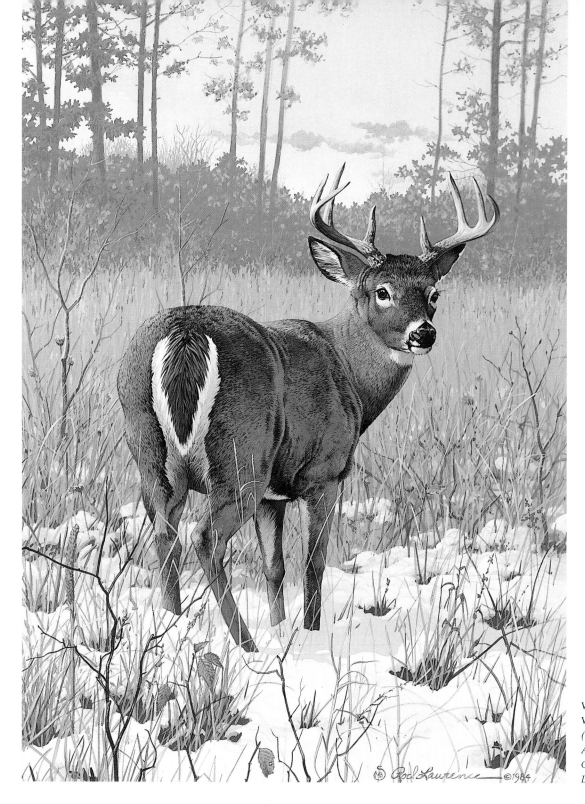

WINTER
WHITETAIL
(White-Tailed Deer)
Acrylic, 9" x 13"
*Collection of Don and
Lynda Lewis*

MUZZLES are the obvious animal counterparts to bills. The muzzle of an animal includes the jaws and nose. Like a bill, the muzzle alone can give a particular animal its own distinctive look. For example, look at the nose and mouth of an elephant or an anteater. These are unique examples but they point out how important the muzzle is to the appearance of the creature.

When you consider how an animal looks when it vocalizes, like a howl, bark, or snarl, you can see how the muzzle also reflects the animal's emotions. And just to make it interesting, some of these muzzles are full of teeth, tusks, fangs and tongues. Add to this the contortions involved sometimes, such as with a bugling elk, and the artist is presented with a mouthful of things to handle!

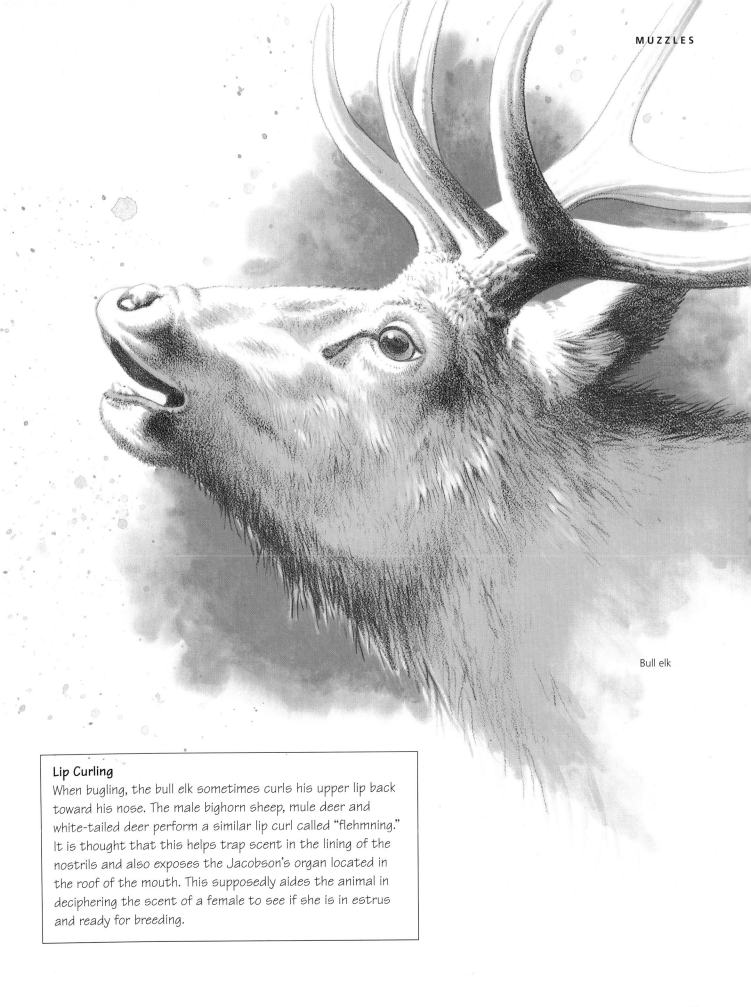

Bull elk

Lip Curling

When bugling, the bull elk sometimes curls his upper lip back toward his nose. The male bighorn sheep, mule deer and white-tailed deer perform a similar lip curl called "flehmning." It is thought that this helps trap scent in the lining of the nostrils and also exposes the Jacobson's organ located in the roof of the mouth. This supposedly aides the animal in deciphering the scent of a female to see if she is in estrus and ready for breeding.

Creating a Moist Muzzle

WHITE-TAILED DEER
(Acrylic)

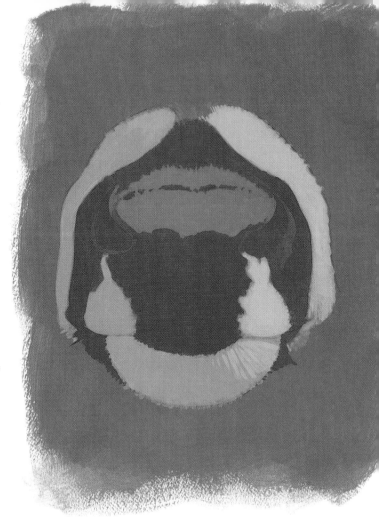

Step 1

Break down the nose into its basic color areas. These are the dark areas, the light areas, and the reflective plane of light on the top. Separate the color of each area into three values: dark, light, and the middle. But for now, use the middle value of each area to block in the basic shapes and patterns of colors. On the left of the nose is a blue-gray middle value that represents the shadow side of the white hair. On the right is the yellow-gray area that represents the middle value of the white hair that is in sunlight. This step uses four middle values of color on top of the brown base.

Step 2

Now use the same values as in Step One to paint some hair details where the colors overlap. Use some slightly darker values to accent the shadows in the dark part of the nose. Add white and Yellow Ochre Light to the lighter value on the right. With this mixture you can paint more hair and lighten the areas that are catching more light. You can also add a lighter value to the reflective light plane on top of the nose, blocking in a small area of white hair commonly found in this area of a deer's nose.

Step 3

Using more Burnt Umber and Ultra-marine Blue to deepen your dark paint, continue to add details and deepen shadows. At this step paint more individual hairs around the nose and also suggest the little dots of hair spots that occur in the dark, middle section of the nose. Again, add more ochre and white to the light paint. Use this paint to indicate more hair and highlights on the right side of the muzzle. A lighter value of the reflected color area on the top of the nose is used to subtly suggest the brighter reflections that meet the dark area in the middle of the nose and especially on the right side.

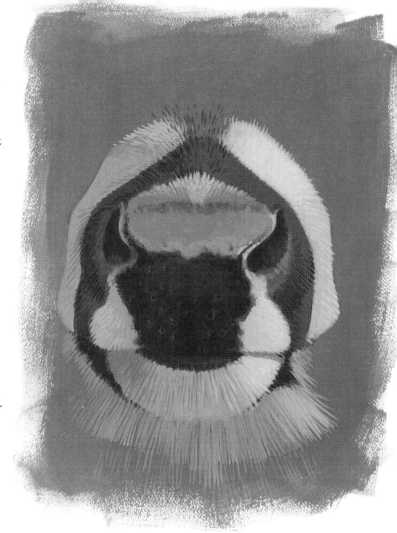

Step 4

It is time to play the aces! Use Ultramarine Blue, Burnt Umber and a little Payne's Gray to make a deep, dark color. This is for the nostril openings and the deepest shadows on the lower side of the muzzle. I use Titanium White with a touch of Cadmium Yellow Light to highlight the brightest areas of sunlight. The last step is to put in the long muzzle hairs.

Muzzle Texture

MOOSE
(Watercolor)

Step 1

To start, do a layout drawing and plan the areas of shadow and sunlight, as well as the basic areas of color. Transfer the major lines of the drawing to your paper. Mix the first set of colors to be used for preliminary washes. Start with five color mixes, two primarily of Burnt Umber and Yellow Ochre, three primarily of Alizarin Crimson, Cerulean Blue and Ultramarine Blue. After wetting only the muzzle area of the paper, I use an old, worn no. 3 round brush to apply some light washes. Be careful to keep the proper color in the right area and to keep the values consistent with the light source.

Step 2

Now use the same colors you mixed previously, but with less water. Using a fairly new no. 3 round sable, that has a nice sharp tip, begin painting with subtle washes, establishing some of the shadow and color edges. This will help make a smooth transition between color areas and changes from light to dark values. You are also starting to suggest hair details with these applications.

Step 3

As in all these steps, be careful to protect your light areas of color. These are crucial for suggesting the light shining on the top of the muzzle and defining the muzzle form. Continue to indicate fur details and increase the use of darker values. Try to give a more three-dimensional look to the muzzle with the increase of contrast. At this point you should also use some subtle washes of Burnt Umber, Yellow Ochre and Cerulean Blue around the bottom opening of the nose, the start of the mouth, and where the dark of the nose blends lighter toward the nasal opening.

Step 4

Here bring out your darkest values consisting of Ultramarine Blue, Burnt Umber and Cerulean Blue. With this, darken the nostril opening, the mouth and the lower jaw. Use this mixture also to work in some darker fur details on the end of the muzzle. Using some clean water on the brush, soften some areas of pigment and blot them with a tissue. This will lighten the area, such as above the mouth line. Use this technique to make some light hairs right in the middle of the muzzle, between the two dark masses.

Feline Muzzle

MOUNTAIN LION
(Acrylic)

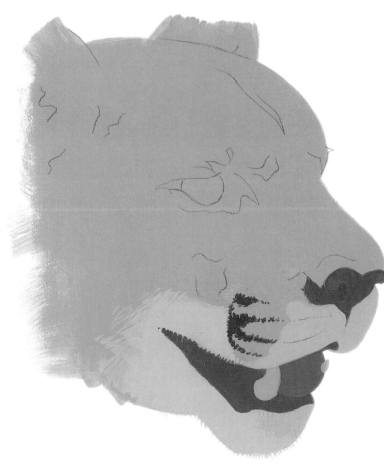

Step 1

To start, paint a solid background color for the head of the mountain lion. This is the general overall color of the head and your starting color and value. Use a no. 2 round brush to define the outline of the cat's head and a ³/₈" bright sable brush to fill the broad area. Use your transfer sheet to establish the major lines from your layout drawing. Then apply paint to the main color areas on the muzzle in a medium value for each area.

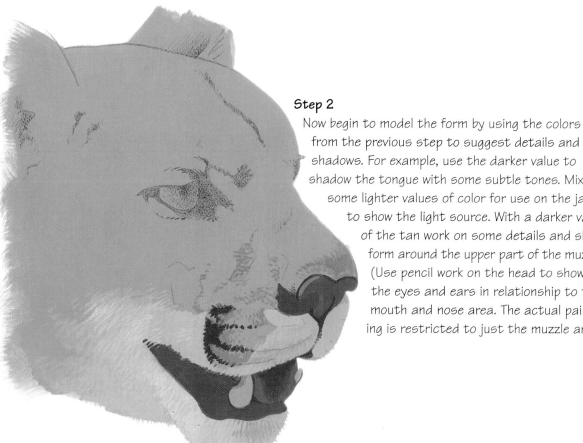

Step 2

Now begin to model the form by using the colors from the previous step to suggest details and shadows. For example, use the darker value to shadow the tongue with some subtle tones. Mix some lighter values of color for use on the jaw to show the light source. With a darker value of the tan work on some details and show form around the upper part of the muzzle. (Use pencil work on the head to show the eyes and ears in relationship to the mouth and nose area. The actual painting is restricted to just the muzzle area.)

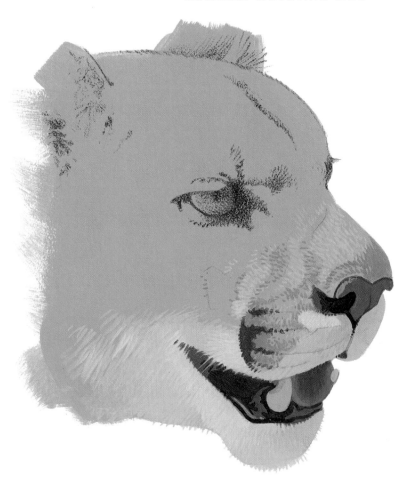

Step 3

The changes are more dramatic in this step. Use darker and lighter values to continue modeling the muzzle. The light values are to show where light is striking the white hair on the muzzle and also to indicate where it is striking the tan hairs around the nose. The darker values of Burnt Umber and Ultramarine Blue are used to increase the contrast and give depth to the lips and mouth opening, as well as the nostrils.

Step 4

Begin the last step by working back and forth with your light and dark paint mixed previously, to continue the suggestion of details. Put more emphasis around the whisker area and just above the nose. Use a mixture of white and a little dab of Cadmium Yellow Medium to apply the brightest areas of light striking the white hairs of the muzzle. Use this for the white whiskers too. Thinning this mixture with water, suggest the highlights on the nose, tongue, and on the dark area below the tooth. The darkest paint completes the final details of the mouth and nose as well as some individual hairs and shadows around the whisker area and nose.

Canine Muzzle

WOLF
(Acrylic)

Step 1

Because of the variation of color in the wolf's head, begin with three opaque colors as a base. The top color is only to indicate the upper "mask" of the head; the tan and light gray comprise the middle value base for the muzzle. After transferring the main features in pencil, paint in the main areas of color with the appropriate middle value for each area. These areas are the mouth, gums, teeth, tongue and nose. These base colors are important to have correct in both value and color, because of the dry brush and washes that will be combined with them.

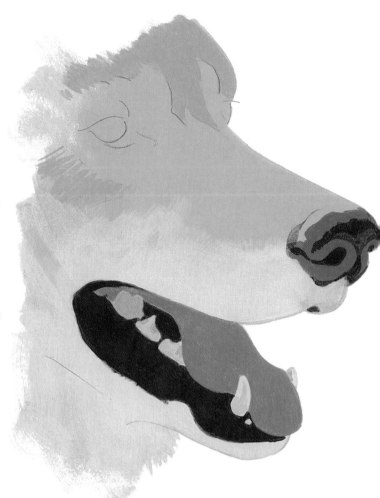

Step 2

Use the colors already mixed to refine the nose with only two values at this point. Then take the blue-gray and paint the suggestion of highlights on the mouth and lips. This begins to suggest the texture of the lips, a moist glossy look. By adding Burnt Umber and Ultramarine Blue to your original tongue color, you create a shadow value. Notice how just the addition of this flat shadow adds a three-dimensional quality to the painting. It gives shape and depth to the tongue and actually gives weight, a feeling of mass to the upper jaw. Use a gray mixture to start work on the shadows under the jaw.

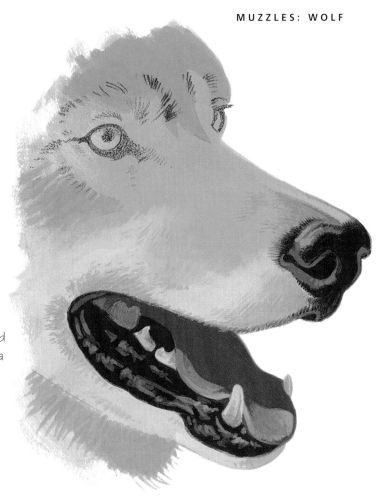

Step 3

For the dark areas, add a lighter, bluer color to continue the painting of highlights. Add white, Cerulean Blue and Ultramarine Blue to the initial tongue color and use this to show highlights on the tongue. In this step also paint gray areas of hair to strengthen the shadows near the nose and under the jaw. Add more Yellow Ochre and Burnt Umber to white and your gray colors to suggest some forms on the teeth. Also mix some of the tongue colors and blue lip highlight colors and use this on the lip area near the teeth. Use a darker value of the tan base to work on the top of the muzzle. This has some Burnt Umber, Yellow Ochre, and Cadmium Orange added to it.

Step 4

For the last step, your dark value should be as dark as needed. Add more highlights. The final white for the muzzle and all bright highlights is white with a slight touch of Yellow Ochre Light and Cadmium Yellow Light. Continue working on the muzzle hair and add Burnt Umber and Ultramarine Blue to get darker and cooler values. To paint the reflected light in the shadow area of the tongue, mix Cadmium-Barium Red Deep with Cerulean Blue, Ultramarine Blue, white, and a touch of Burnt Umber. Because this is a close view of the muzzle, I thought this additional detail would be interesting to add.

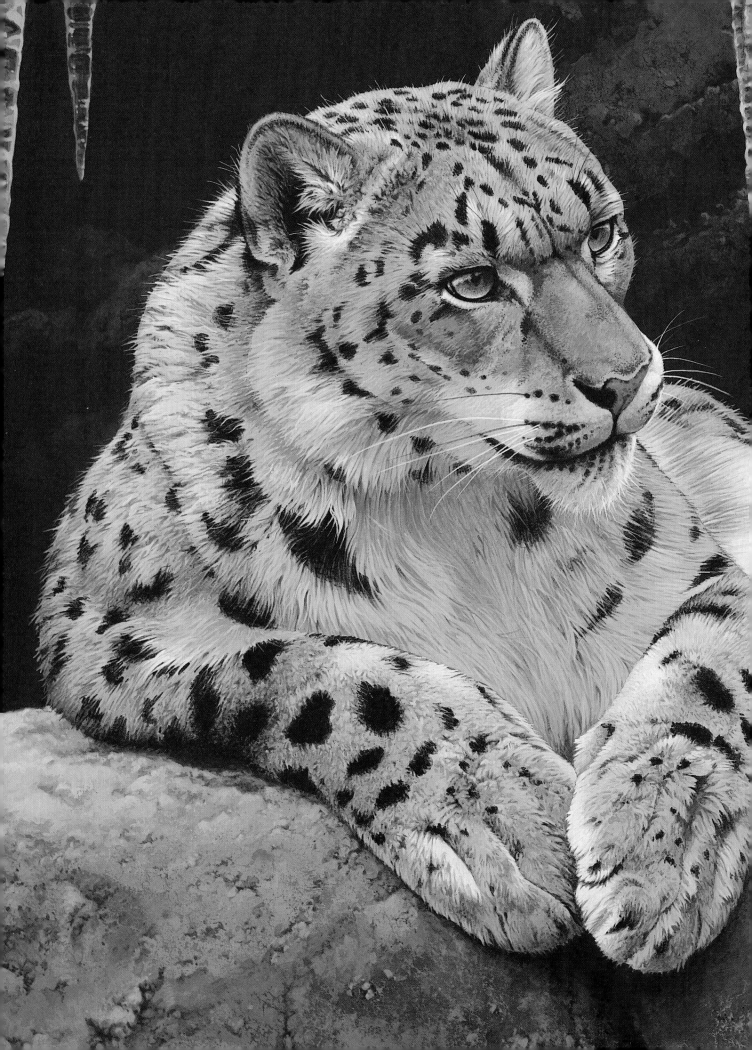

6

TAILS & FEET

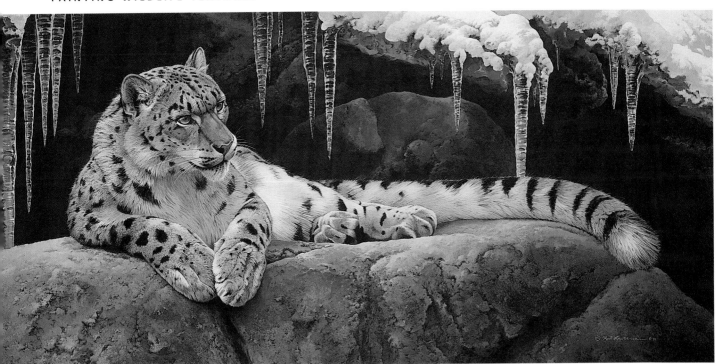

ICE PALACE
(Snow Leopard) Acrylic, 22" x 48", Collection of Philip and Barbara Lawrence

FEET in many instances do not appear in a painting of wildlife. They are often hidden by the habitat, such as grass, snow, water or even the body of the species. However, sometimes artists purposely hide the feet in their paintings. They apparently do not know how to paint them or feel it would be easier just to hide them. Often this avoidance of painting feet is painfully obvious to the viewer; the painting looks contrived around the feet, like the artist was indeed trying to hide them. Obviously, feet should not be ignored if the situation in the painting calls for them to be visible. Time should be taken to research those particular feet and then properly paint them into the picture. As with all other appendages, the relationship to the body in proportion and placement is very important.

Form and function of the feet are definitely related. The feet tend to be specialized for the animal's specific uses, such as running, swimming or grasping. Some are even more specialized to the animal's particular habitat, like rocky terrain or snowy conditions.

wolf paw and mouse

MALLARD FOOT
(Acrylic)

Redhead

Mallard

One example of form following function in regard to feet is the difference between the puddle or "dabbling" ducks and the "diving" ducks. The divers, such as the redhead, have feet that are located further back on the body than a dabbling duck like a mallard. This helps the redhead when diving underwater for food, but also makes them a bit more awkward when trying to walk on land. Although both have webbed feet for swimming, the diver has a skin lobe attached to the hind toe, which is missing on the hind toe of a dabbling duck.

Step 1
For a mallard's foot, first do a fairly solid, opaque layer of paint in a middle color value. The color is based on a Cadmium-Barium Orange.

Step 2
Using a darker color value, (dark enough to see well, but not too bold), begin to define the form by suggesting shadows and darker details. This is a good time to use thin washes to show subtle color changes on the foot.

Light source

Step 3
Use a lighter value, (light enough to see well, but again not too bold), and start to indicate highlights and lighter detail areas. Full form, light and dark should be quite apparent now.

Step 4
This is the final phase and time to really refine the foot. Emphasize the brightest areas of light and the darkest areas of shadows. Keep the direction of the light source constant.

99

Painting Feet

TALONS: BALD EAGLE
(Watercolor)

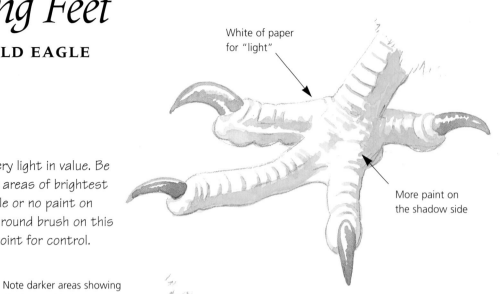

White of paper for "light"

More paint on the shadow side

Step 1
The first wash is very light in value. Be careful to keep the areas of brightest light clean with little or no paint on them. I use a no. 2 round brush on this step, with a good point for control.

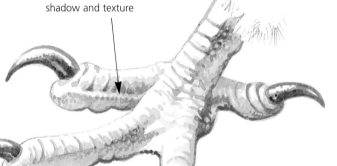

Note darker areas showing shadow and texture

Step 2
Using a darker value (with a little Burnt Umber and Cerulean Blue to tone it down), begin to establish the darker shadows and show more detail. Always look for the forms and textures that give a good idea of the texture of the foot.

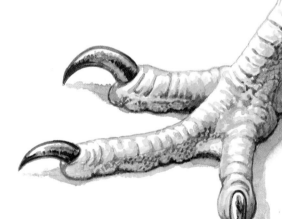

Step 3
The last step is to make sure the light and dark areas make sense in terms of the light source and forms. Be sure to clarify the foot texture, not create questions about the foot's appearance or feel.

HOOF: WHITE-TAILED DEER
(Oil)

Step 1
Use a thin mixture of Burnt Umber and turpentine to paint the foot and basic shadows.

Step 2
Apply a medium range of full color values over all areas. With oils, always save your lightest values for last so you can keep them clean for greater impact in the final step. Your concern here is color, form, light and shadow, not detail.

Step 3
I use a no. 3 round sable brush to do this entire step. Drag paint in and out of areas to suggest detail, such as the hair on the foot where it changes from light to shadow. Add some individual hairs of both lighter and darker values and blend the areas of color in the hoof so they are more subtle.

Add highlights to the hoof, both on the front where the strong light is and also on the back, right-hand side. This is reflected light, bouncing back onto the dew claw and hoof. This entire demonstration is painted without allowing any of the paint to dry between steps.

Painting Paws

SNOW LEOPARD
(Acrylic)

Step 1

Use a thin wash of color, keeping brush-
strokes in the direction of the hair
growth. Several washes like this
build up paint and give very
subtle indications of brush-
strokes that you can
use as hair to build
on later.

Step 2

A mixture of Burnt Umber and Cerulean Blue
added to the paint mixture from Step One will
give a nice value to start working on shadows
and details.

Wash in the "spots," keeping
the brushstrokes and hair
direction in mind. This is
a dark value, but still
not the darkest paint
I will be using.

Use a lighter value wash on the underside
of the paw for reflected light.

Step 3

With a no. 2 round brush, begin applying both lighter and darker values to the paws. Concentrate on making the forms round and creating a feeling of mass.

Step 4

Use darker washes to show individual hairs and the overlapping of dark and light hairs around the "spots." Also use this dark value to build up the shadows and make them more opaque.

The lightest values will accent the texture, showing light on the fur and some individual hairs to keep the edges soft and furry.

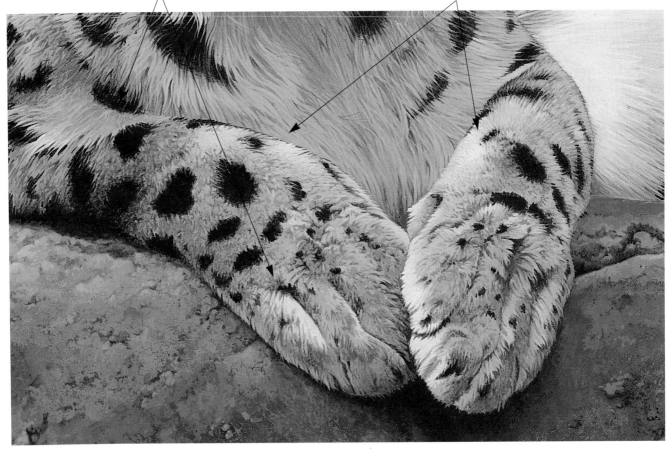

Detail of *Ice Palace* (page 98)

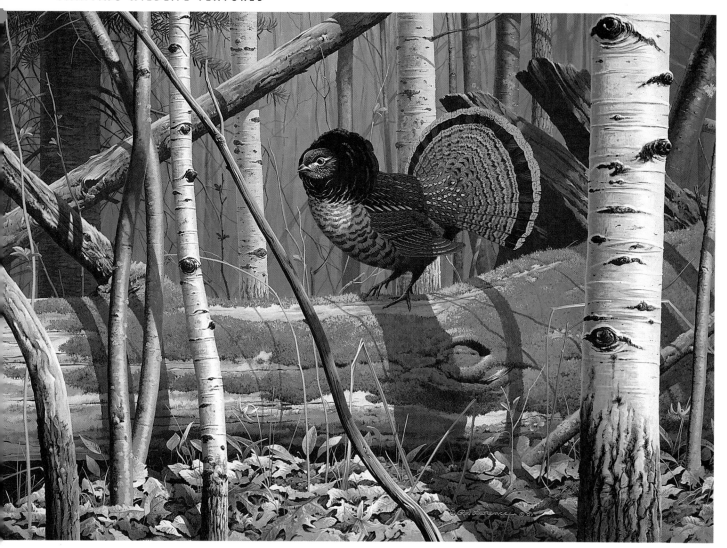

THE DRUMMING LOG
(Ruffed Grouse) Acrylic, 18" x 27", Collection of Dr. Jeff Methany

TAILS can be more important to wildlife than one might think. Usage varies according to species, but they are used for such things as rudders, signaling, warmth, display, conveying social status or just swatting insects.

Tails also come in a variety of textures and some with intricate detail as well; textures are varied in both feathers and fur. This chapter will offer several examples and show you how to paint tails that look like they could actually be touched.

WHITE-TAILED DEER
(Acrylic)

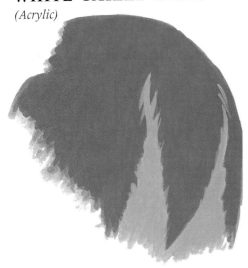

Step 1
Build an opaque medium value using several layers of thin paint. This is a mixture of Burnt Umber, Yellow Ochre Light, a touch of Cadmium-Barium Deep and Cerulean Blue.

> The white-tailed deer is one of those species that uses its tail as a signal. By raising its tail to expose a broad expanse of white hair, it can show other deer in the area that it is alarmed.

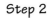
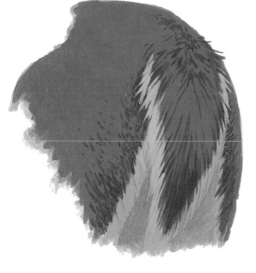

Step 2
For darker areas of hair, add Ultramarine Blue and Burnt Umber to darken and cool the value. Use this to detail and emphasize texture. On the lighter areas, add Burnt Umber and Cerulean Blue to darken shadow areas. When painting the details, keep in mind the light source and shadows, as well as the texture.

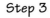
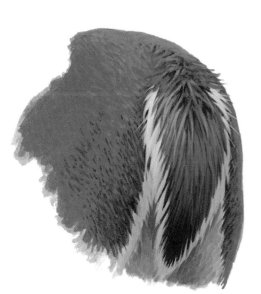

Step 3
Use a no. 1 round brush to further the detail work. Darken the shadows and sharpen the hair texture details. On light areas, add more light by using a mix of white and ochre. The really dark values are Burnt Umber and Ultramarine Blue with some Cadmium-Barium Red Deep.

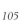

Tail Texture–Fur

RED FOX
(Watercolor)

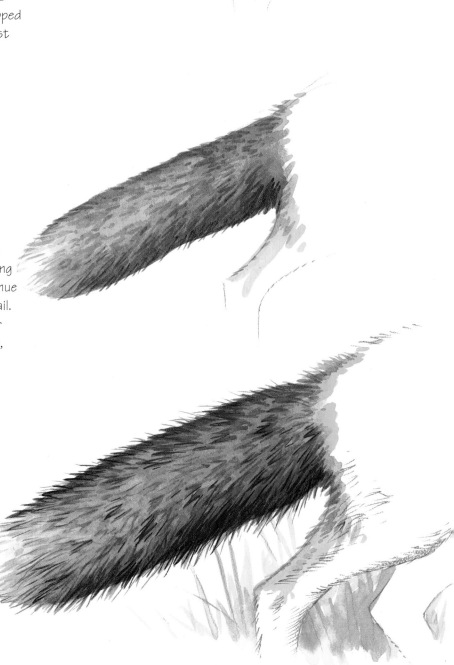

Step 1

For the fox tail, first wet the paper in the area of the tail, leaving the white tip dry. Then use a wash of three color values, the lightest and warmest on top, the darker, cooler one under the tail for shadow. Use a sharp-tipped brush, like a no. 1 or no. 2 round, to suggest some hair areas before totally dry.

Step 2

Some washes of Burnt Sienna accent the tail and indicate deeper areas of fur. Adding Burnt Umber and Ultramarine Gray, continue to do the same to the underside of the tail. For the white tip, use a blue-lavender color made from Burnt Umber, Ultramarine Blue, Cadmium-Barium Red Deep, and Cerulean Blue. I darken this to show the shadows and some individual hairs.

Step 3

Add some single hairs to the leading edges and deepen the dark areas to make more pronounced shadows. These are the final fur details.

RED SQUIRREL
(Acrylic)

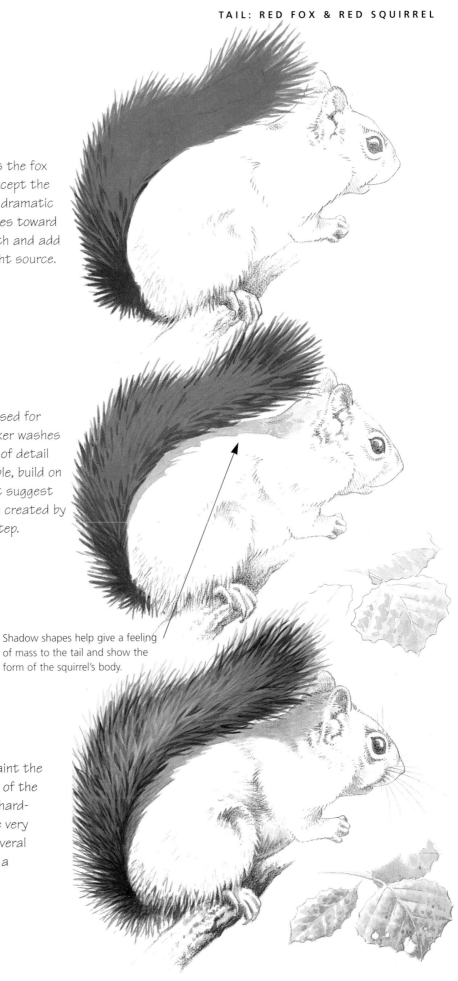

Step 1
This is the same approach as the fox tail on the preceding page, except the color changes are a bit more dramatic on the squirrel. Keep the values toward the middle range to start with and add shadows according to the light source.

Step 2
Here some thin washes are used for subtle shading and then darker washes are used for rendering areas of detail and shadow. Whenever possible, build on sections of the painting that suggest interesting forms, which were created by the washes in the previous step.

Shadow shapes help give a feeling of mass to the tail and show the form of the squirrel's body.

Step 3
Use a no. 1 round brush to paint the light wispy hairs on the edge of the tail (helping to break up the hard-edged look). Accent both the very dark and very light areas. Several coats may be needed to get a broad solid area quite dark.

Tail Texture–Feathers

RUFFED GROUSE

(Acrylic)

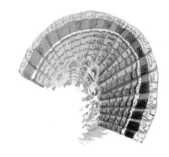

> Ruffed grouse have two color phases, red and gray.
> The grouse in the painting *The Drumming Log*
> (page 104) and the tail at right are of the red
> phase. The demonstration below is the gray phase.

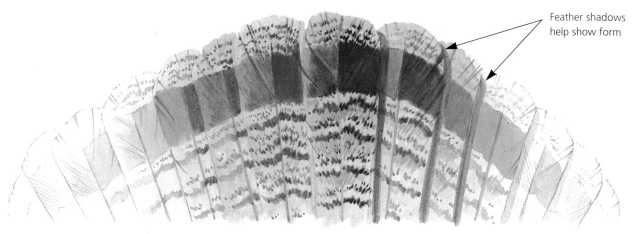

Feather shadows
help show form

Step 1
Use a base coat of medium value to make simple blocks
of colors on each feather to show the tail pattern.

Step 2
Use thin washes of darker values to paint some details
and feather shadows.

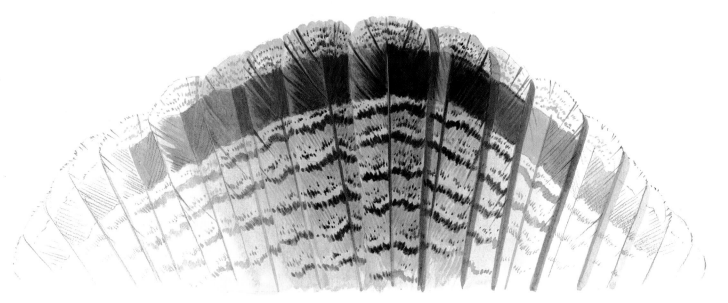

Step 3
Using washes of thin paint, indicate feather breaks
along the edges and ends of feathers to give the paint-
ing a more feathery texture. Also, use lighter washes to
set off some feather breaks with highlights.

Step 4
Now, refine all the shadows and feather breaks by using
the lightest and darkest values. Finish the details with
fine lines for somewhat irregular pattern edges. The
slight sheen on the dark areas of the feathers is a very
light wash of blue-white paint and water.

EASTERN TURKEY
(Acrylic)

Juvenile turkeys have center tail feathers
that are longer (right). Adult tail feathers
are all similar in length (left).

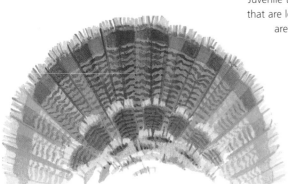

Step 1
Start with a solid base of medium values to establish shapes and an area of simplified feather colors. Use minimal detail.

Step 2
Use darker color changes to render feather markings and shadows, as well as feather breaks. This will give the tail some textural feeling and start to define form as well.

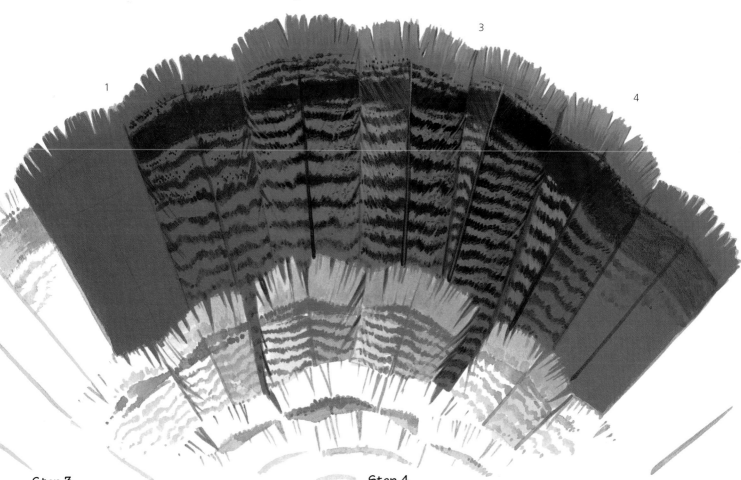

Step 3
Now use thin, semi-transparent washes to suggest color changes due to light and shadow on individual feathers. Detail some of the feather markings, keeping the edges soft, irregular, and follow the direction of the feather structure.

Step 4
Again, use the light blue-white wash to highlight the dark feather band and parts of the feathers. The deepest dark values are used to accent the shadows and details, creating the strongest contrast in color and value.

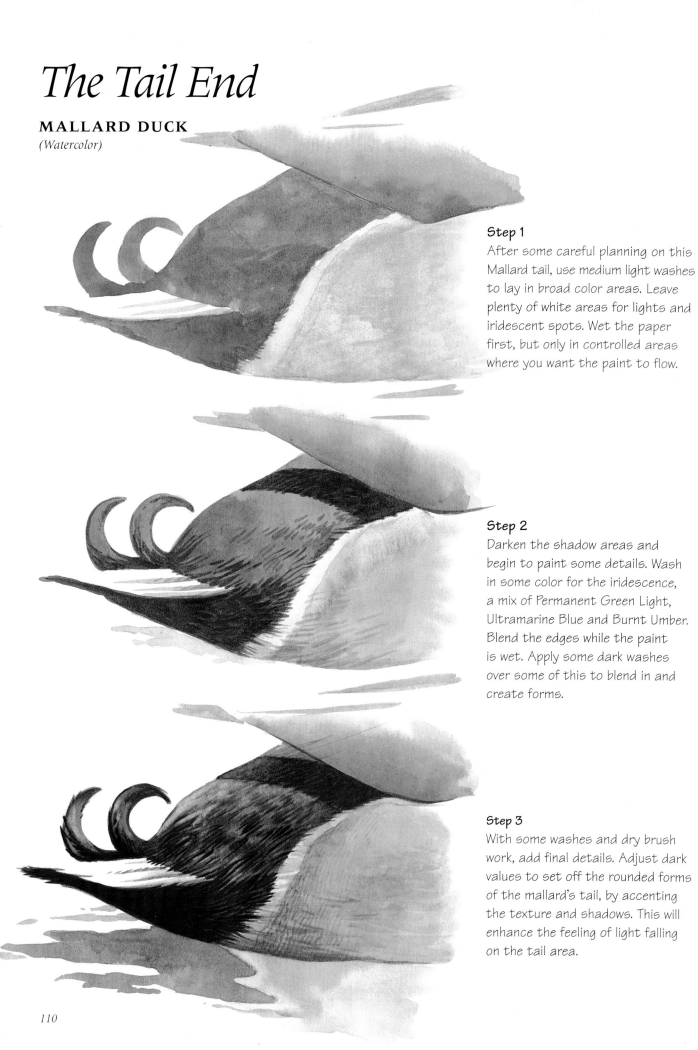

The Tail End

MALLARD DUCK
(Watercolor)

Step 1

After some careful planning on this Mallard tail, use medium light washes to lay in broad color areas. Leave plenty of white areas for lights and iridescent spots. Wet the paper first, but only in controlled areas where you want the paint to flow.

Step 2

Darken the shadow areas and begin to paint some details. Wash in some color for the iridescence, a mix of Permanent Green Light, Ultramarine Blue and Burnt Umber. Blend the edges while the paint is wet. Apply some dark washes over some of this to blend in and create forms.

Step 3

With some washes and dry brush work, add final details. Adjust dark values to set off the rounded forms of the mallard's tail, by accenting the texture and shadows. This will enhance the feeling of light falling on the tail area.

BLUE JAY
(Acrylic)

Step 1

While keeping the white and light areas of the Jay in mind, wash in light values of blue with subtle shading and color variations. Use grays to shadow and form the underside of the tail and body. Keep the gray wash light and slightly warm (using some Yellow Ochre Light in the mix).

Step 2

Use a deep gray-brown wash of Burnt Umber, Ultramarine Blue, Cerulean Blue, white, and a little Cadmium-Barium Red Deep and wash in shadows and the dark tail markings. Start with thin washes and build them up.

Step 3

Continue using washes of the darker value to strengthen the deep shadows and detail feather breaks and pattern edges.

Step 4

With a no. 1 round sable brush, refine the details and sharpen the contrast between light and dark. Add those extra individual strokes to emphasize the feather texture.

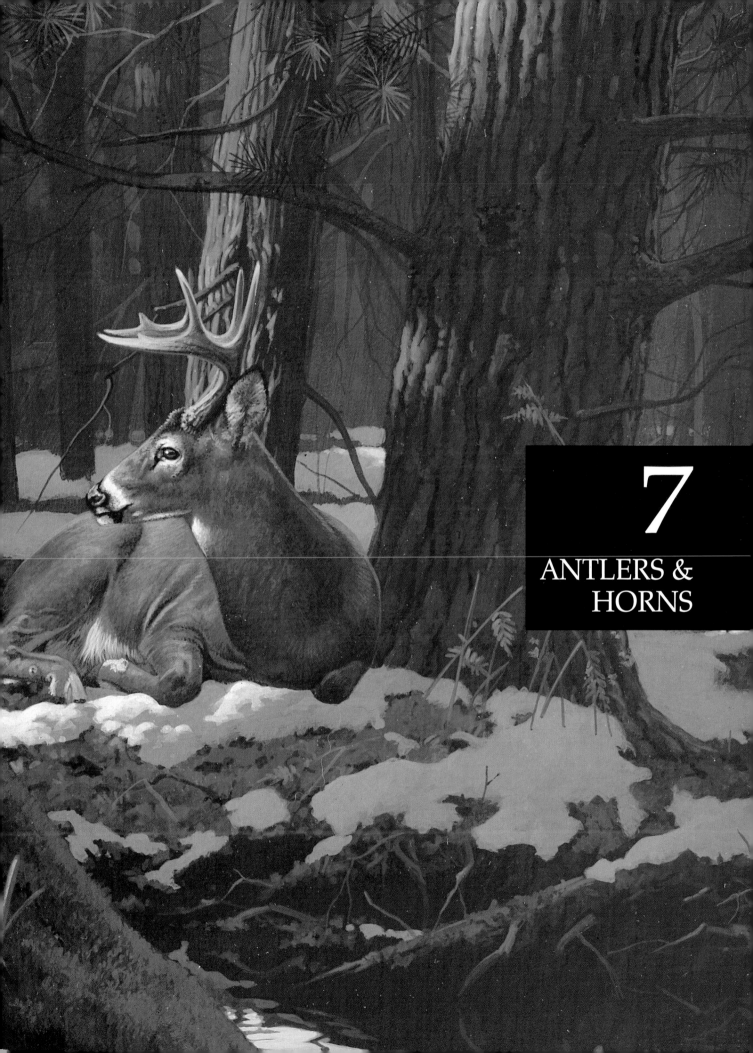

7

ANTLERS &
HORNS

ALONG THE CREEK
(White-Tailed Deer) Acrylic, 14" x 18"

ANTLERS are a key part of many wildlife paintings. A
large majestic rack of antlers seems to hold a certain
romantic fascination for many people and consequently
such animals are frequently painted. The importance of
antlers to a painting is obviously decided by their rela-
tive size and shape as they appear in the painting.
Antlers have a unique texture, due in part to the way
they grow and by the way the animal uses them. They
are generally smooth on the outer tips and rough,
grooved, and even knobby at the tines around the
base. I find antlers to be very interesting to paint or

draw. The surface irregularities make them wonderful
for a texture study. Reference is usually easy to come
by as well. Most people have access to antlers from a
hunter, garage sale, or a lucky find. I tend to clutter up
my studio with antlers and skulls. I used some of them
to do the demonstrations in this book.

The further away the antlers in your painting appear,
the less evidence of texture should be shown. A few
simple indications of form and texture can convey the
necessary effect. When your painting has an antlered
animal up close, then texture and detail can become
very important.

Horns and Antlers Differ in Several Ways

Antlers are a bone-like growth, although they have no internal nerves or blood supply. Instead, during growth they are nourished by an outer skin covering called "velvet" that grows with the antler. When growth is complete, the velvet dies and comes off. Later, at the end of the breeding season, the antler itself is shed at the base near the animal's skull. The process will then repeat itself. Horns are a growth, or covering sheathes over a bony inner core that grows out of the skull. They are usually not shed and continue to grow each year. The exception to this is the pronghorn. More information about the pronghorn is on page 124-125.

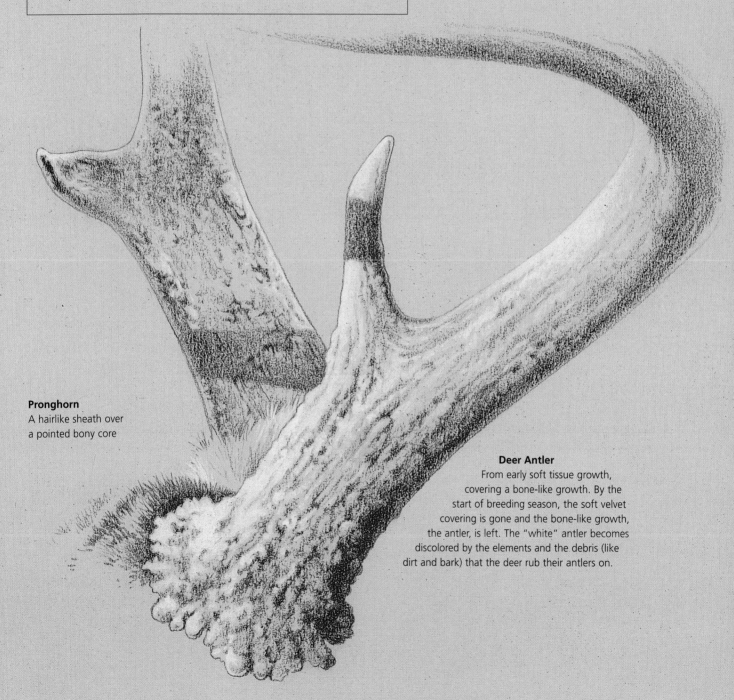

Pronghorn
A hairlike sheath over
a pointed bony core

Deer Antler
From early soft tissue growth,
covering a bone-like growth. By the
start of breeding season, the soft velvet
covering is gone and the bone-like growth,
the antler, is left. The "white" antler becomes
discolored by the elements and the debris (like
dirt and bark) that the deer rub their antlers on.

115

Painting Antlers

DEER
(Acrylic)

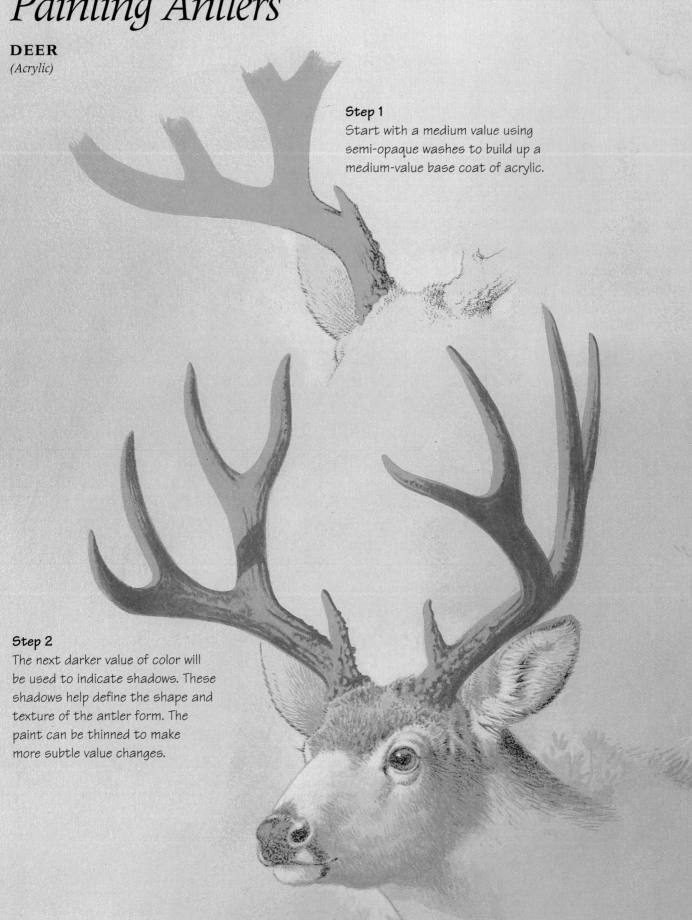

Step 1
Start with a medium value using semi-opaque washes to build up a medium-value base coat of acrylic.

Step 2
The next darker value of color will be used to indicate shadows. These shadows help define the shape and texture of the antler form. The paint can be thinned to make more subtle value changes.

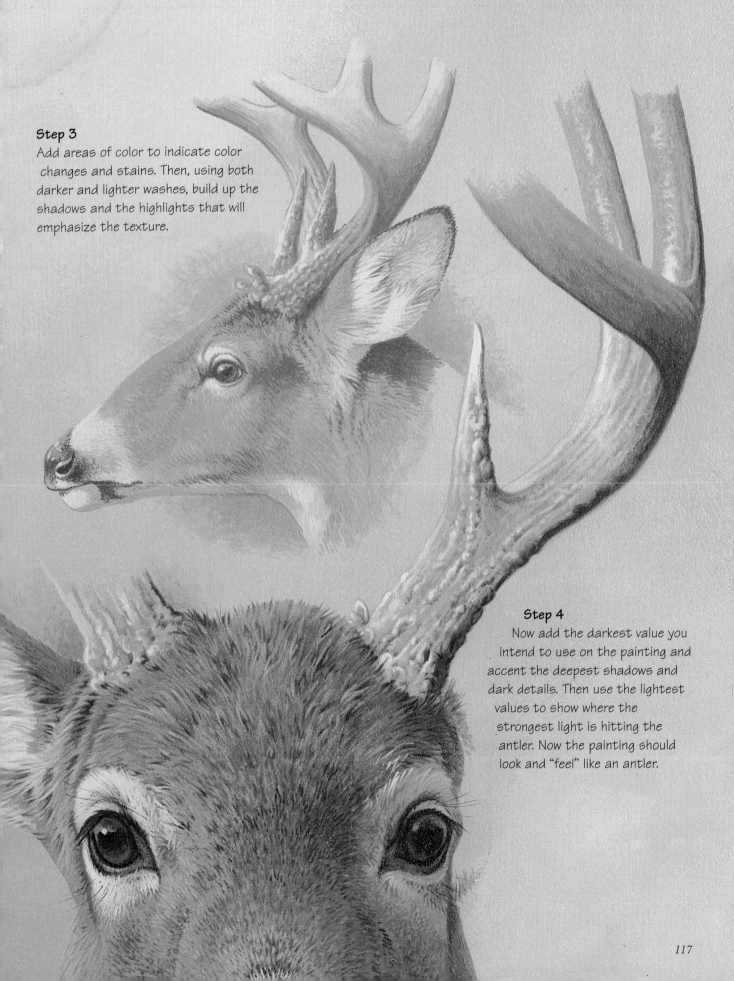

Step 3
Add areas of color to indicate color changes and stains. Then, using both darker and lighter washes, build up the shadows and the highlights that will emphasize the texture.

Step 4
Now add the darkest value you intend to use on the painting and accent the deepest shadows and dark details. Then use the lightest values to show where the strongest light is hitting the antler. Now the painting should look and "feel" like an antler.

Painting Antlers

MOOSE
(Watercolor)

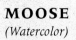

Step 1

Wet the paper in the antler shape, to control the flow of paint. Use a thin wash of warm color, very light in value, and block in the form.

Leave some areas of white for the light, sunny areas of the antler.

Step 3

Using a slightly darker value, still a warm tone, begin defining the basic shadows to give the antlers some form.

Brush in some other color spots. These color stains are caused by the many things the moose has rubbed his antlers in.

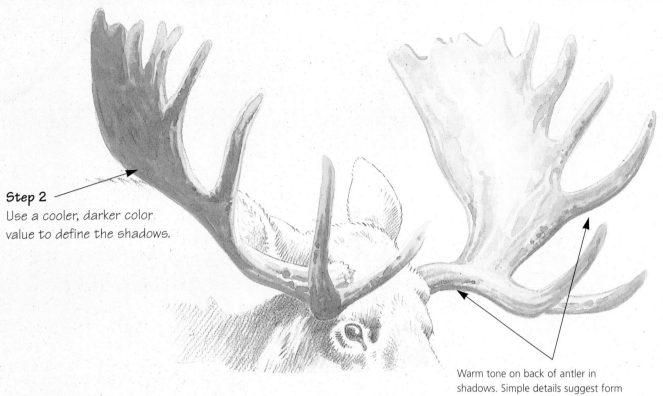

Step 2
Use a cooler, darker color value to define the shadows.

Warm tone on back of antler in shadows. Simple details suggest form

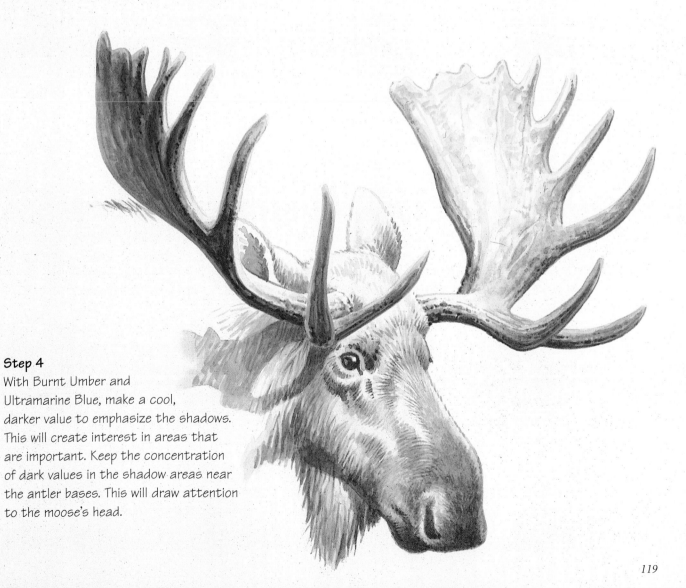

Step 4
With Burnt Umber and Ultramarine Blue, make a cool, darker value to emphasize the shadows. This will create interest in areas that are important. Keep the concentration of dark values in the shadow areas near the antler bases. This will draw attention to the moose's head.

Antlers vs. Horns

Antlers and horns can differ individually, within the same animal families. For example, males of both mule deer and white-tailed deer grow antlers, but not in the same shape. In some mammal species, both male and female have horns or antlers, but each is shaped differently. These differences are very important to painting accurate wildlife paintings. Carefully research whatever species you are working on, before you start painting.

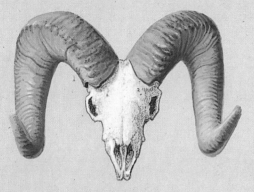

The bighorn has thick, tighter curled horns and larger body size.

The Dall sheep have a slender body and slender curled horns.

Typical Antlers

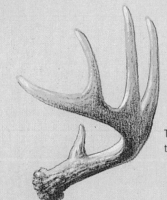

Tines branch off the main beam.

White-tailed deer antlers are formed with one main beam.

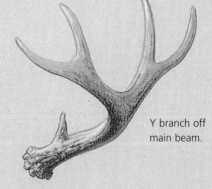

Y branch off main beam.

Mule deer antlers typically form a "Y" off the main branch.

Non-typical antlers

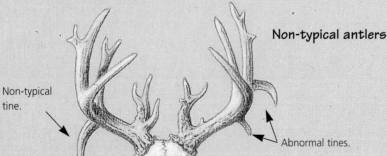

Non-typical tine.

Abnormal tines.

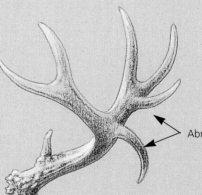

Abnormal tines.

Non-typical antlers are called such because of the growth of tines in abnormal places. These growths usually appear in particular areas of the antlers.

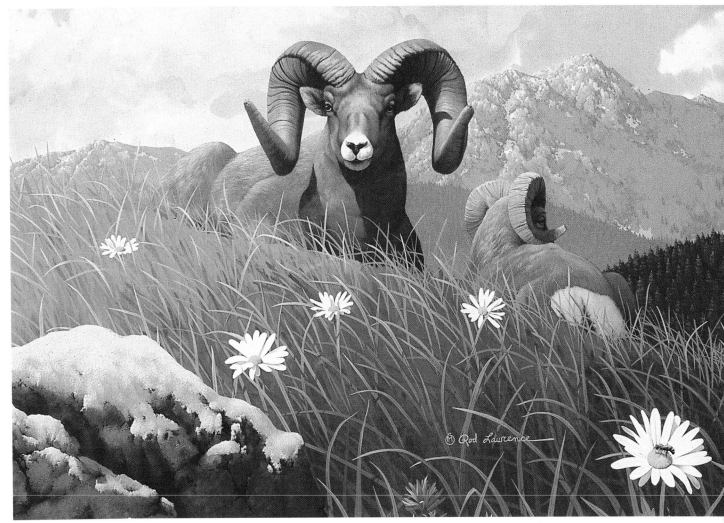

WHERE THE WIND IS COOL AND THE SUN IS WARM
(Bighorn Sheep) Gouache, 16" x 24", Private Collection

HORNS share the same intrigue as antlers when it comes to putting them into a piece of wildlife art. Often a large trophy-size set of horns is portrayed. After all, most people do not want a picture of an animal with a set of small, scrawny horns. Usually, we want to show something of the magnificence of a healthy creature in his prime. As a consequence, these horns draw attention and become a focal point. Because of this, when painting horned wildlife,

the horn's characteristic shape, proportions, and texture are very important to the painting.

For both antlers and horns, detailed texture is more important in compositions where the animal is large and close to the picture's foreground. In this case, the texture is generally more obvious where the structure grows out of the animal's head. Along with color and value, light and shadow also play a key part in painting antler and horn texture.

Creating Horn Texture

BIGHORN SHEEP
(Acrylic)

Step 1
Paint a medium value color on the entire horn.

Step 2
Use a slightly darker value to paint some simple details and shadows. Keep in mind the surface shape and pattern of growth rings.

Step 3
Begin using values both lighter and darker than Step Two. Use these to develop more form and show where light is striking the horn surface.

Step 5
The final step is to use the lightest and darkest values to really accent areas. This is minor work, but has a major impact in bringing out the forms and defining the texture.

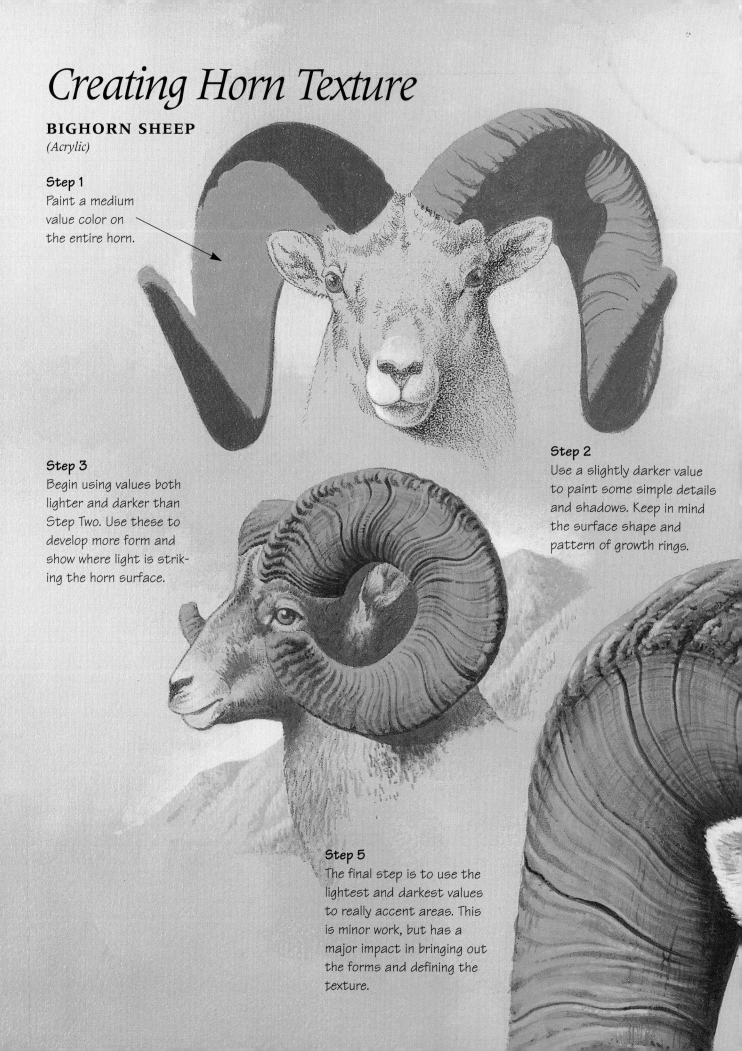

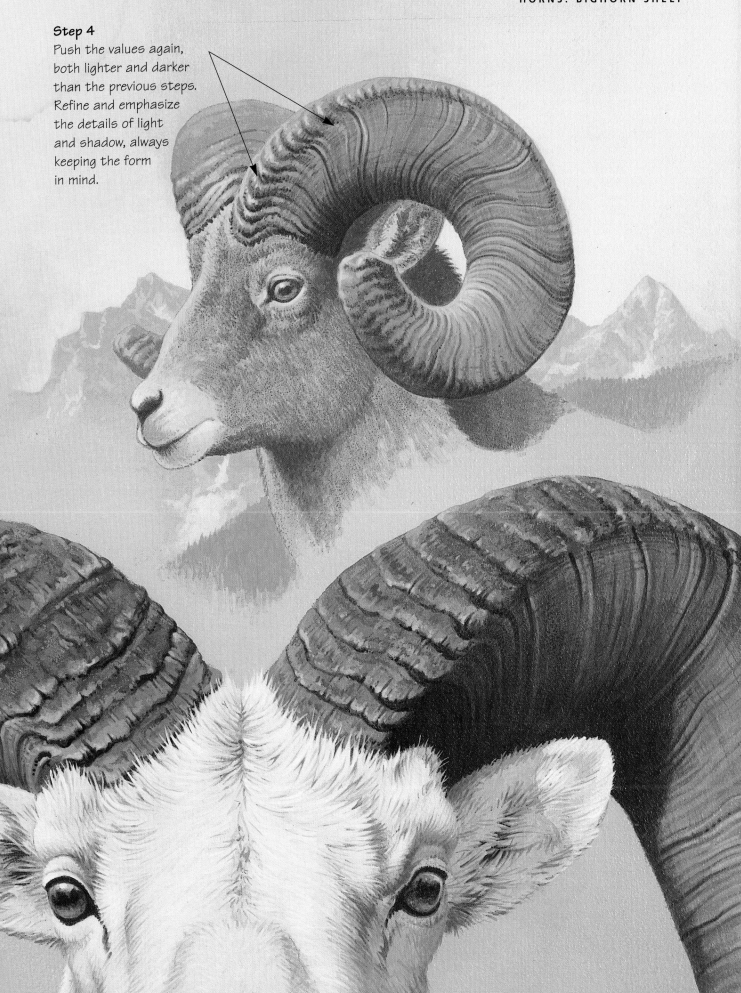

Step 4
Push the values again, both lighter and darker than the previous steps. Refine and emphasize the details of light and shadow, always keeping the form in mind.

Painting Horns

PRONGHORN
(Oil)

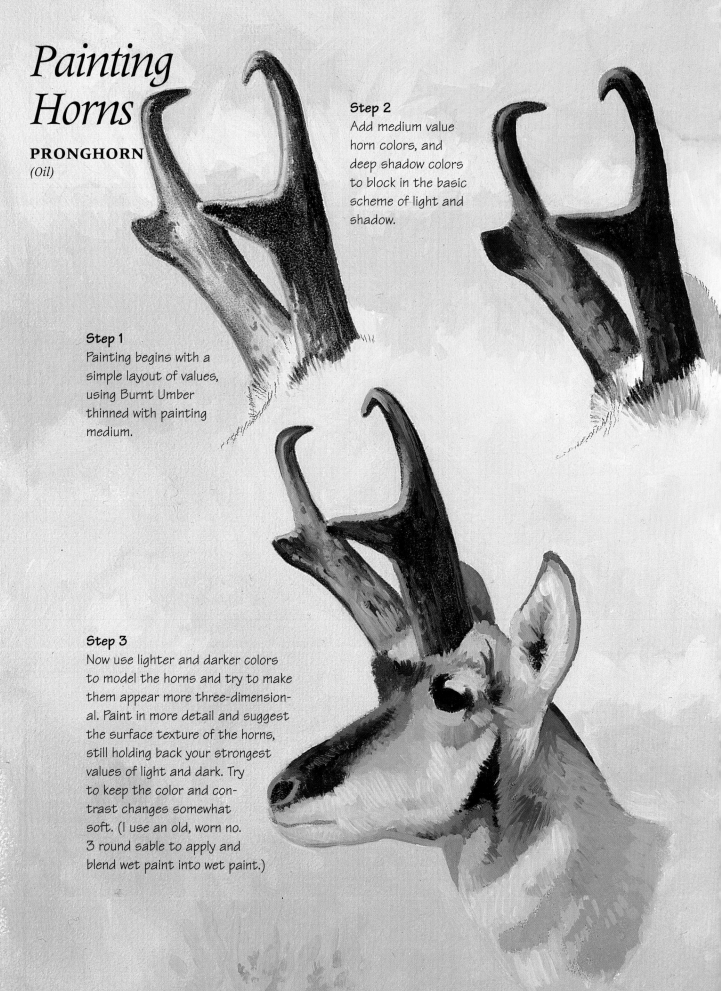

Step 2
Add medium value horn colors, and deep shadow colors to block in the basic scheme of light and shadow.

Step 1
Painting begins with a simple layout of values, using Burnt Umber thinned with painting medium.

Step 3
Now use lighter and darker colors to model the horns and try to make them appear more three-dimensional. Paint in more detail and suggest the surface texture of the horns, still holding back your strongest values of light and dark. Try to keep the color and contrast changes somewhat soft. (I use an old, worn no. 3 round sable to apply and blend wet paint into wet paint.)

Step 4

Before this step, allow the painting to dry a few days, until the surface is dry to the touch so you can add textural details without disturbing the rest. Use thin paint as well as some dry brush and wet-on-wet blending for these details. Add some brownish colors to the horns and then start using the darker values to define shadows and texture. When you are satisfied with the effect, use the lighter blue-gray values to indicate the light reflecting off the horn surface and producing highlights on the texture. When totally dry, you may like to put a clear finish over the painting to bring back the rich, wet look of the paint.

The pronghorn is an exception to several characteristics common to hoofed animals. Its horns are the only horns that actually form branches, or prongs. And unlike other horns, the pronghorn's are shed each year. Underneath the horn is a pointed bone-like core that regenerates a new horn sheath from the tip each year. Another pronghorn exception: Both antlered and horned hoofed animals have two hoof cloves and, slightly higher up on the leg, two dew claws on each foot. The pronghorn does not have these dew claws.

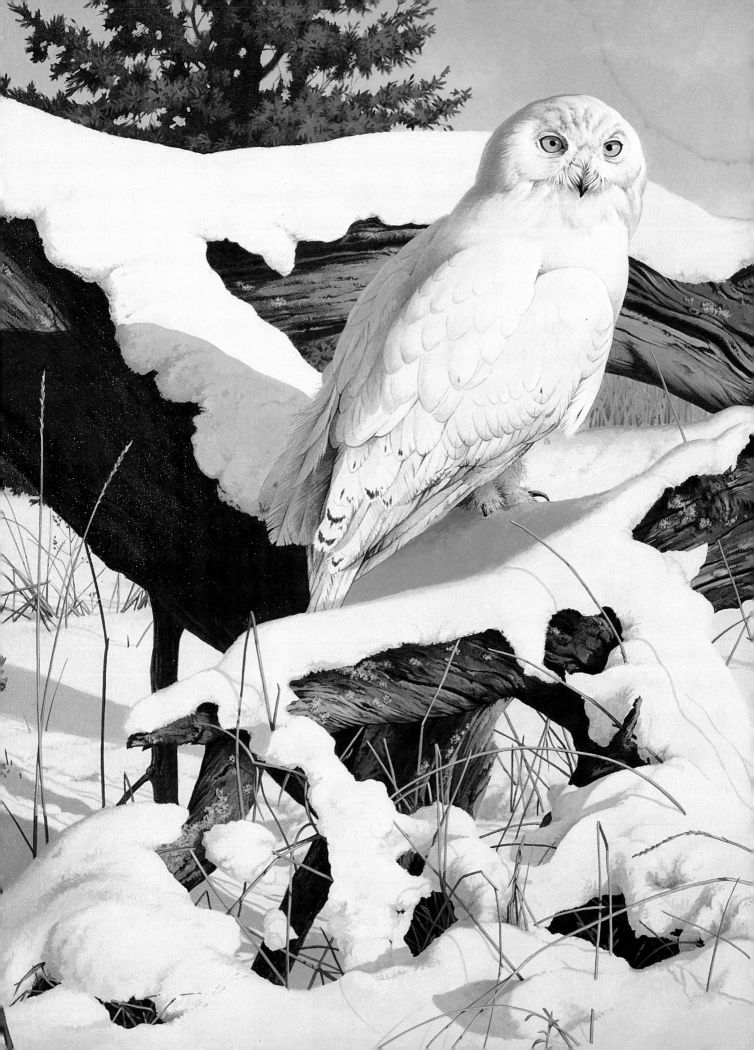

8

WHITE & BLACK
SUBJECTS

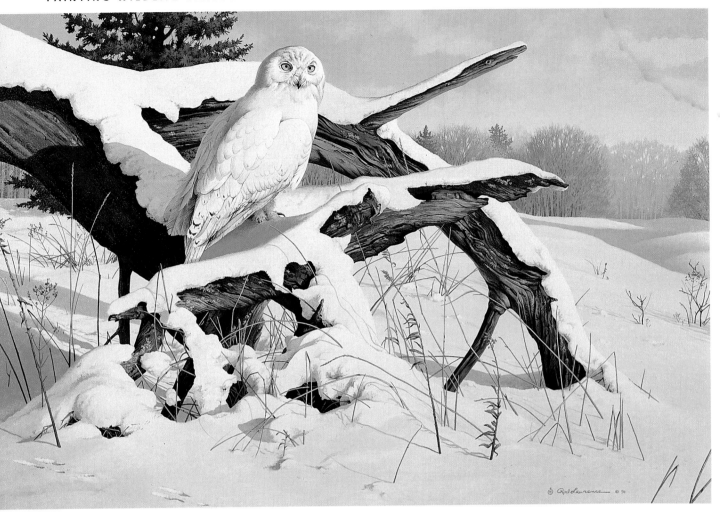

SNOWY ARENA
(Snowy Owl)
Acrylic, 19" x 38", Collection of Angelo R. Arena

WILDLIFE subjects that appear to be, or are, entirely

black or white can be a real challenge to paint. If you have been fortunate enough to see a black bear in the wild, you know that at first glance you only see a moving black shape. Any color or change of values come only from the light reflections on the animal's body. On a bright sunny day, you would see more value changes and the sheen of the animal's fur. The same is true, but perhaps less obvious, on white wildlife. Even in low light conditions, where there is much less light reflection, to paint one of these creatures as just a silhouette would not be very interesting or enjoyable. I think these subjects look more three-dimensional with contrasts of color and value. If the values are similar with little change, then the object appears flat.

A good example of how light reflection affects color is the appearance of shadows on snow. On sunny days, with a deep blue sky, the shadows reflect that blue sky color and appear more blue. When the sky is overcast, but there is still enough light to cause shadows, these shadows look more gray and not so intense. The same is true of shadows on white wildlife.

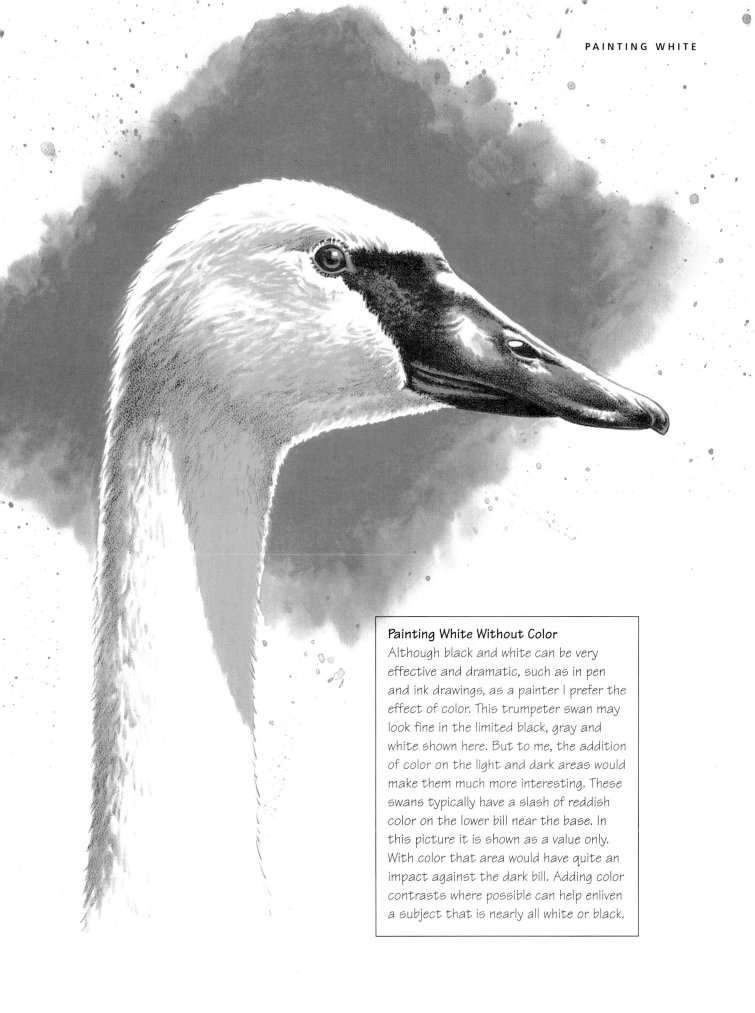

Painting White Without Color

Although black and white can be very effective and dramatic, such as in pen and ink drawings, as a painter I prefer the effect of color. This trumpeter swan may look fine in the limited black, gray and white shown here. But to me, the addition of color on the light and dark areas would make them much more interesting. These swans typically have a slash of reddish color on the lower bill near the base. In this picture it is shown as a value only. With color that area would have quite an impact against the dark bill. Adding color contrasts where possible can help enliven a subject that is nearly all white or black.

Painting "White" Texture

POLAR BEAR
(Acrylic)

Step 1

I use a no. 2 round brush for this whole demonstration. The coat of fur on a polar bear is not really white, it is more of a cream color. Start with a mix of white, Cadmium Yellow Medium, Yellow Ochre Light and a very small dab of Burnt Umber and Cadmium-Barium Red Deep as your base color. Then mix your first shadow color, adding Burnt Umber, Cerulean Blue and Ultramarine Blue to the original paint mixture for a darker and cooler value. Use this to "draw" and begin to develop the bear's head structure. Keep the brushstrokes going in the direction of the fur so that you can build on them later. As you can see, the first applications are somewhat transparent. (The eye and nose are only blocked in with a deep gray to establish their location on my painting for reference.)

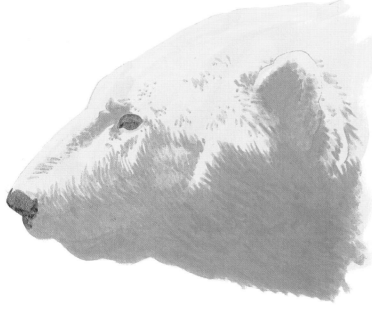

Step 2

Continue to use the shadow mixture and build up some areas to a more opaque look. Add some thin washes of a red-brown on parts of the head, especially around the ears. Use another shadow value that is just a bit darker to work on some areas of the fur that you want to enhance with deeper values later. The value changes are still subtle and easy for you to adjust. You can see this color around the eye, the ear, and especially on the area of the neck below the ear.

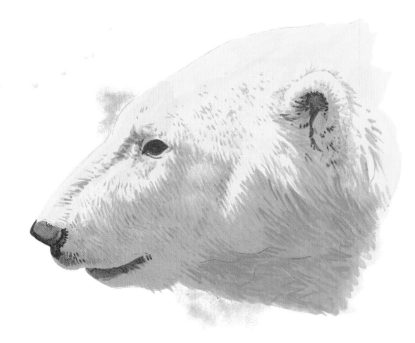

Step 3

Continue to develop some details with your darker shadow values in this step. By adding Burnt Umber, Cerulean Blue and Ultramarine Blue, you can darken these values and still keep them in the general color scheme. The paint for these shadows is applied as both washes and opaque layers. Now introduce some dark values to begin modeling the nose, mouth and eye.

Start to add a blue wash behind the bear to help set off the head. When you add the whiter highlights later, they will contrast with the background for a better effect.

Step 4

Use more Burnt Umber and Ultramarine Blue to make the darker fur shadow values around the muzzle, eye, and ear, defining fur details. Also use a browner version of this on the lower neck fur area. After using your final dark on the eye and muzzle, add some bluish highlights. The final application of paint is the light playing on the top of the head. This is a mixture of white, with a dab of Cadmium-Barium Light along with the cream base color started with. This takes several layers of paint to build up the effect.

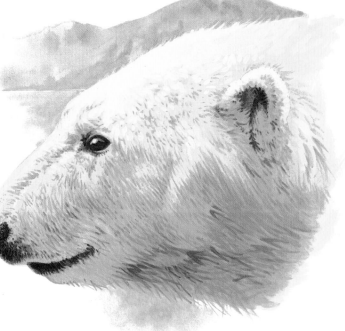

White

TUNDRA SWAN
(Watercolor)

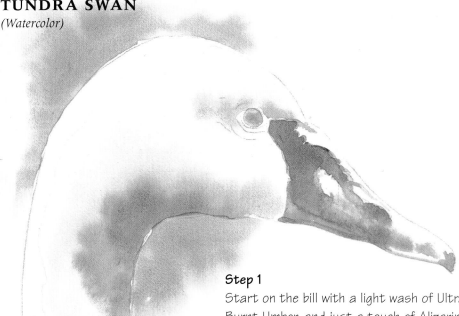

Step 1

Start on the bill with a light wash of Ultramarine Blue, Cerulean Blue, Burnt Umber, and just a touch of Alizarin Crimson. Leave the brightest area of light white. Wet only the area of the bill that will receive the light wash. Follow this procedure in each of the areas that you are working on. Next, use the same mix with more Alizarin Crimson and apply a light wash to suggest the shadows of the swan's neck and eye area. Use a light wash of Yellow Ochre, Cerulean Blue and Burnt Umber to create a warm background behind the head. This will help to set off the white head and neck.

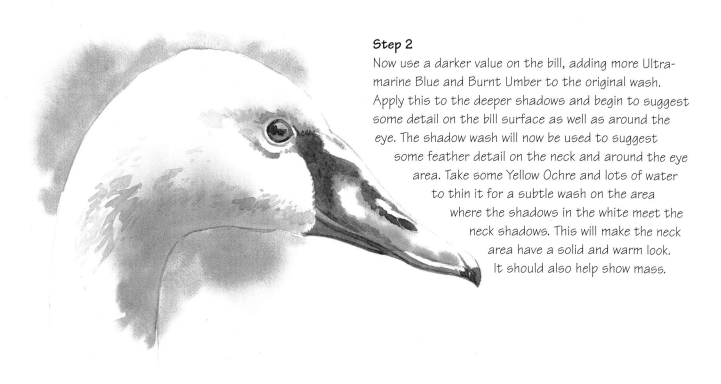

Step 2

Now use a darker value on the bill, adding more Ultramarine Blue and Burnt Umber to the original wash. Apply this to the deeper shadows and begin to suggest some detail on the bill surface as well as around the eye. The shadow wash will now be used to suggest some feather detail on the neck and around the eye area. Take some Yellow Ochre and lots of water to thin it for a subtle wash on the area where the shadows in the white meet the neck shadows. This will make the neck area have a solid and warm look. It should also help show mass.

Step 3

Add darker values of the neck shadow colors to the area around the eye and under the head. Use these deeper colors to continue the suggestion of feather details and to give a better indication of the head and neck structure. With less water and more pigment, use the darker paint on the bill and to strengthen the shadows. Apply a gray-pink wash over the lighter areas of the bill. At this point, use a small round sable brush with clean water to lift the paint on the bill just in front of the eye. Blot this with a tissue and then do the same on the edge of the lower mandible. Repeat this step a few times until you have a clean white area in both sections.

Step 4

Use a wash of Cadmium Yellow Pale and paint the lifted area in front of the eye. Shade this a little with Yellow Ochre where it meets the bill on the right. Use Cadmium Scarlet and Burnt Umber to make a subtle wash along the lower jaw. With Ultramarine Blue, Burnt Umber and Alizarin Crimson, mix a very dark value with little water. This very dark paint is for the final details on the eye and bill. Some of the bill areas can be softened with clean water and blotted to produce some lighter highlights. The last step is to increase the value of the neck shadows and strengthen the area under the head and neck. The same paint should be applied around the eye to finish the details there.

133

WALTER
(German Short-Haired Pointer) Acrylic, 9" x 13", Collection of Dr. Norman Licht

DOGS are not what some would consider "wildlife," but I thought the painting above is a good example of a black animal subject. Sometimes our pets can be great subjects for drawing and painting. Locating a black bear or black panther to study and paint can be difficult. Finding a black house cat, horse or Labrador retriever can be relatively easy.

They all present the same challenge in painting a very dark creature. Black or really dark subjects reflect a small amount of light and have no predominant color hue. This painting of a German short-hair dog shows how the bright sun reflects off the hair and head structure to produce highlights. In low-light conditions, I use some "artistic license" to emphasize the reflected light.

Painting "Black" Texture

BLACK BEAR FOOT
(Acrylic)

Step 1

This is the left front foot of a black bear. Start with a medium to dark value and paint the entire foot except for the claws. The first layer is semi-transparent as on the left side. The overlapping paint strokes already suggest hair clumps. Keep the brushstrokes in the direction of the fur. Continue with a more opaque surface. The right side of this foot shows two or three coats of paint, with which you will cover the rest of the foot. Fill in the claws with one application of paint.

Step 2

Mix a fairly dark value, but still light enough that the final dark will contrast with it. Check this by making a paint swatch of the two colors, so you can check the value difference between them. With this begin painting the shadowed areas of the foot. Notice how to suggest the claws and toes under the fur with the dark paint. This helps establish a space between each toe and follows the flow of hair. Add both a darker and lighter value on the claws to start building some form.

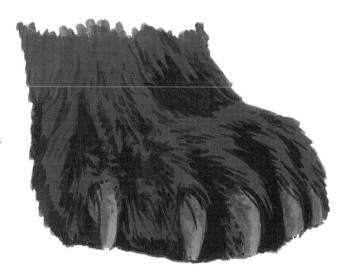

Step 3

The final dark paint is Ultramarine Blue and Burnt Umber. Use this to make the shadows recede more and accent some of the fur. Mixing Cadmium-Barium Red Deep, white and Cerulean Blue with the base color gives you a lighter value to begin adding highlights to the top of the toes. Lighten this with white in several steps and apply glazes to build highlights on the fur clumps. The claws are worked in a similar way, except using Burnt Umber and Yellow Ochre to keep the color correct.

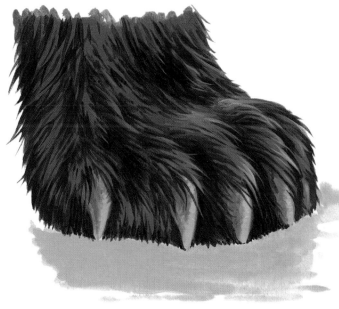

Black

CAPE BUFFALO
(Acrylic)

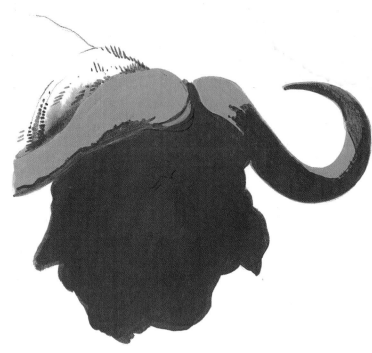

Step 1

Begin with two solid base colors. Each is a middle value for its particular color area, based on the range of values that you anticipate using in each area. One is for the light colored horns and the other for the dark body. The body color is Cerulean Blue, Burnt Umber, Ultramarine Blue and Titanium White, with some small amounts of Yellow Ochre Light, Cadmium Orange and Cadmium-Barium Red Deep. Mix some more brown into your blue-gray body color while the paint is still wet on the board. It is subtle, but you want some of this brown to show and you will add to it later. Use the body color as a first step in rendering shadows on the horns.

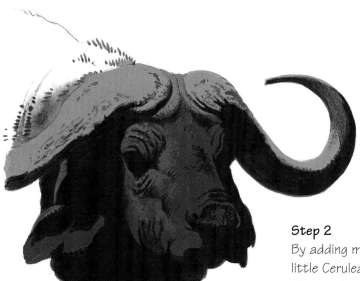

Step 2

By adding more Burnt Umber, Ultramarine Blue and a little Cerulean Blue to the body color, create a mixture that is the next darker value for painting. This value is easily seen in contrast to your base color and will still be a good contrast for a near black color to be applied later. Use this to paint shadows and some details. Extend this dark color into the horn shadows as well. Now mix the next darker value of the horn color and use it to suggest a few details on them. Also use this and a browner mixture to enhance the area around the eye. This can suggest dust, dirt, or color change on the head and it begins to model the head forms.

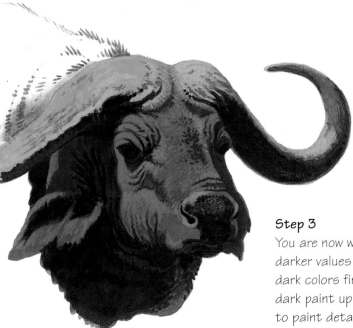

Step 3

You are now working in two directions. You are intensifying darker values as well as your lighter values. Work with the dark colors first and then move to the lighter colors. Move dark paint up another step, yet still not to black. Use this to paint details in the shadowed areas. Use some lighter grays and blue colors to highlight what would be raised areas that catch the light. These are around the eyes and muzzle, as well as the ear. On the horns add a lighter value to help establish where you want to emphasize light and dark. Before starting the next step, continue to use these paint values to refine the painting. At this point, render everything to near completion, although it is obviously lacking the final step.

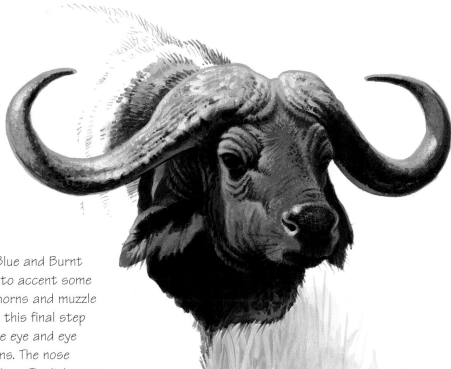

Step 4

The "black" to use now is Ultramarine Blue and Burnt Umber. Paint the eye with it and use it to accent some deep lines under the neck, around the horns and muzzle area. Use several lighter color values in this final step also. First, build up the light around the eye and eye shadows, then do the same on the horns. The nose has some smaller areas that also build up. The lightest values are reserved for the horns and the nose. After several value steps, the last one is a mixture of white with just a touch of Cadmium Yellow and Yellow Ochre Light. The final touch is adding hair detail to the forehead, ears, and neck.

Black

CANADA GOOSE
(Watercolor)

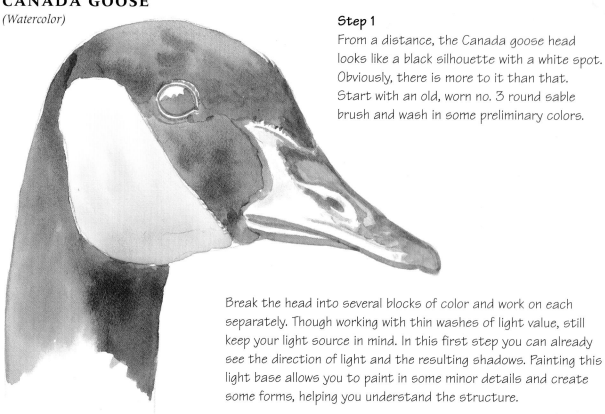

Step 1

From a distance, the Canada goose head looks like a black silhouette with a white spot. Obviously, there is more to it than that. Start with an old, worn no. 3 round sable brush and wash in some preliminary colors.

Break the head into several blocks of color and work on each separately. Though working with thin washes of light value, still keep your light source in mind. In this first step you can already see the direction of light and the resulting shadows. Painting this light base allows you to paint in some minor details and create some forms, helping you understand the structure.

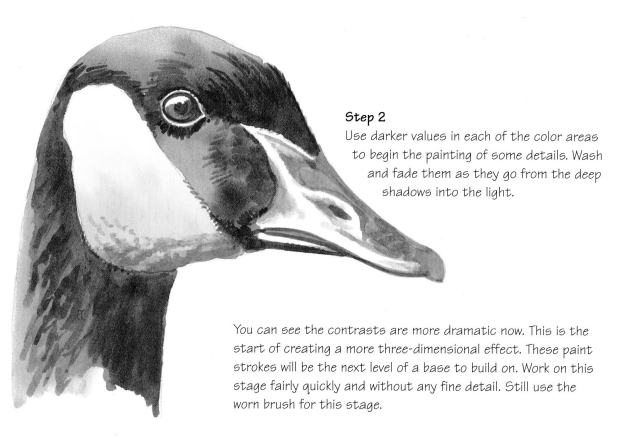

Step 2

Use darker values in each of the color areas to begin the painting of some details. Wash and fade them as they go from the deep shadows into the light.

You can see the contrasts are more dramatic now. This is the start of creating a more three-dimensional effect. These paint strokes will be the next level of a base to build on. Work on this stage fairly quickly and without any fine detail. Still use the worn brush for this stage.

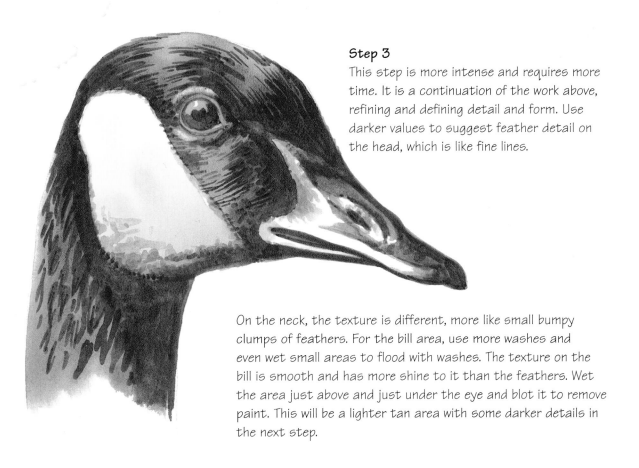

Step 3

This step is more intense and requires more time. It is a continuation of the work above, refining and defining detail and form. Use darker values to suggest feather detail on the head, which is like fine lines.

On the neck, the texture is different, more like small bumpy clumps of feathers. For the bill area, use more washes and even wet small areas to flood with washes. The texture on the bill is smooth and has more shine to it than the feathers. Wet the area just above and just under the eye and blot it to remove paint. This will be a lighter tan area with some darker details in the next step.

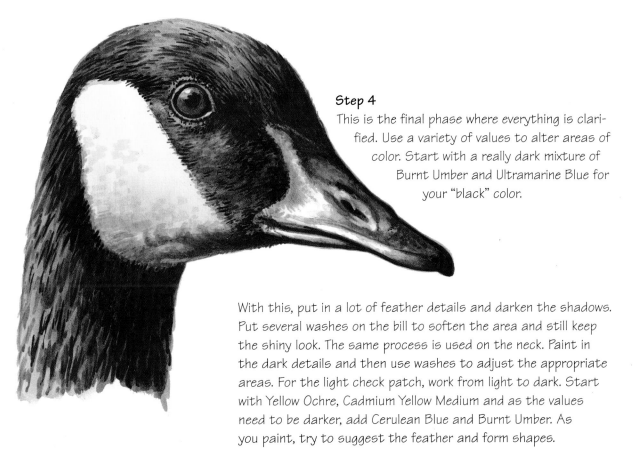

Step 4

This is the final phase where everything is clarified. Use a variety of values to alter areas of color. Start with a really dark mixture of Burnt Umber and Ultramarine Blue for your "black" color.

With this, put in a lot of feather details and darken the shadows. Put several washes on the bill to soften the area and still keep the shiny look. The same process is used on the neck. Paint in the dark details and then use washes to adjust the appropriate areas. For the light check patch, work from light to dark. Start with Yellow Ochre, Cadmium Yellow Medium and as the values need to be darker, add Cerulean Blue and Burnt Umber. As you paint, try to suggest the feather and form shapes.

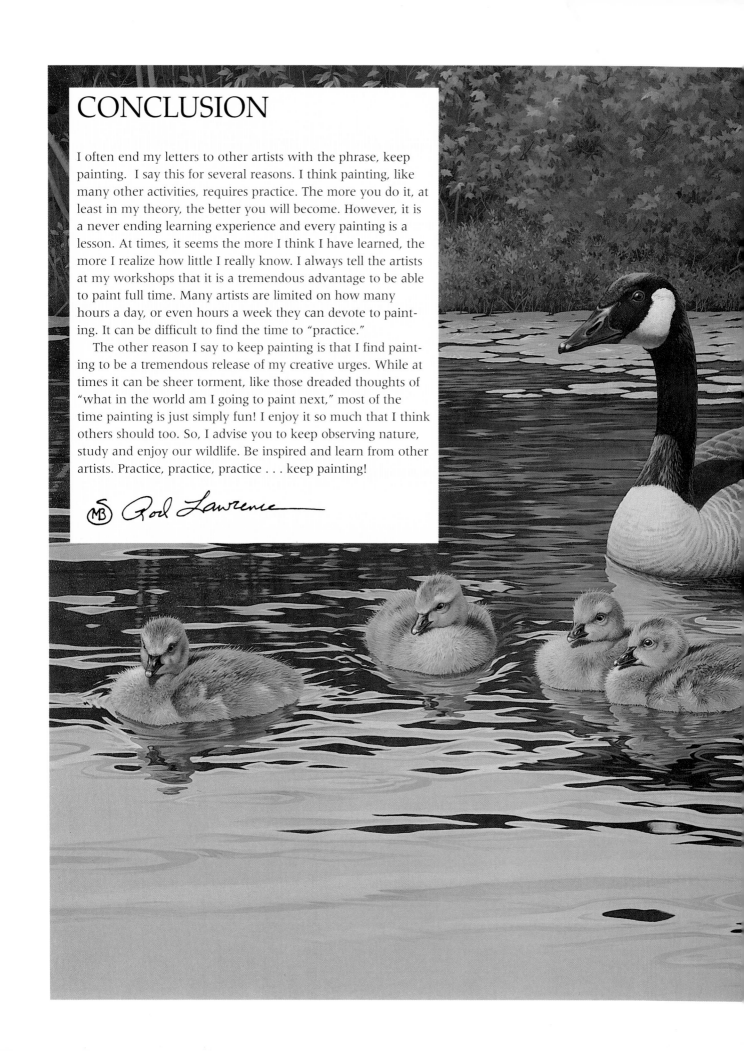

CONCLUSION

I often end my letters to other artists with the phrase, keep painting. I say this for several reasons. I think painting, like many other activities, requires practice. The more you do it, at least in my theory, the better you will become. However, it is a never ending learning experience and every painting is a lesson. At times, it seems the more I think I have learned, the more I realize how little I really know. I always tell the artists at my workshops that it is a tremendous advantage to be able to paint full time. Many artists are limited on how many hours a day, or even hours a week they can devote to painting. It can be difficult to find the time to "practice."

The other reason I say to keep painting is that I find painting to be a tremendous release of my creative urges. While at times it can be sheer torment, like those dreaded thoughts of "what in the world am I going to paint next," most of the time painting is just simply fun! I enjoy it so much that I think others should too. So, I advise you to keep observing nature, study and enjoy our wildlife. Be inspired and learn from other artists. Practice, practice, practice . . . keep painting!

Rod Lawrence

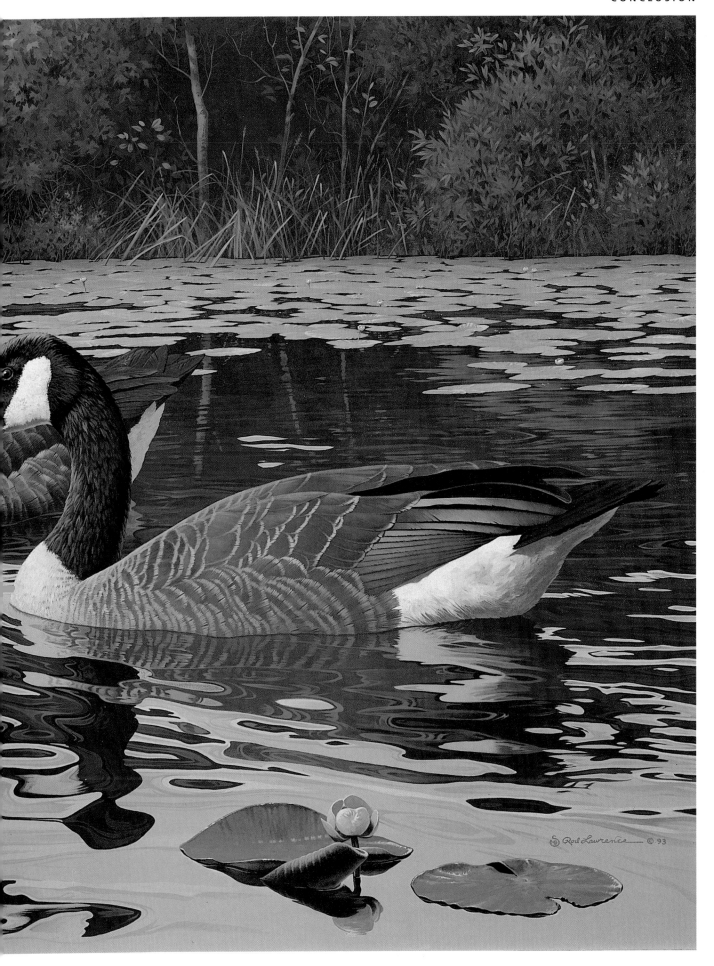

INDEX